Around
Montgomery

D0862187

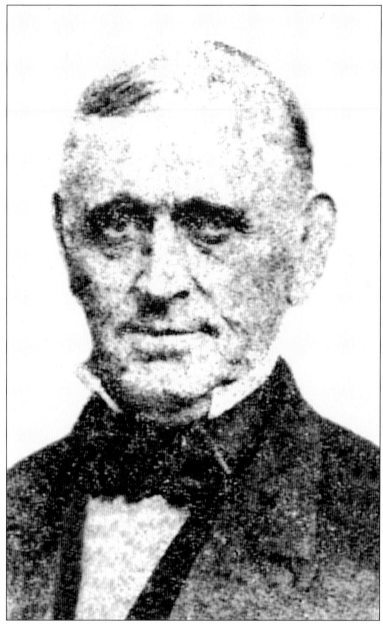

In 1854, when the village known as Clinton Mills needed land upon which to build a railroad station, Robert Montgomery (pictured above) offered a parcel near his hotel on Main Street. The railroad stop, and eventually the town, became known as Montgomery Station. (Courtesy of the Montgomery Area Public Library.)

On the front cover: The former William Decker home in Montgomery is a landmark that is often described as "the mansion." For more views, please see page 19. (Courtesy of Lynn Ditty.)

On the back cover: The members of Montgomery's Citizens Military Band are identified on page 125. (Courtesy of Montgomery Area Historical Society.)

POSTCARD HISTORY SERIES

Around Montgomery

Joan Wheal Blank

ARCADIA
PUBLISHING

Published by Arcadia Publishing
Charleston SC, Chicago IL, Portsmouth NH, San Francisco CA

Printed in the United States of America

Library of Congress Catalog Card Number: 2007935810

For all general information contact Arcadia Publishing at:
Telephone 843-853-2070
Fax 843-853-0044
E-mail sales@arcadiapublishing.com
For customer service and orders:
Toll-Free 1-888-313-2665

Visit us on the Internet at www.arcadiapublishing.com

Dedicated to all who call Montgomery home.

CONTENTS

Acknowledgments 6

Introduction 7

1. Borough Streets and Homes 9

2. People and Places 23

3. At School 51

4. At Church 63

5. At Work and Play 71

6. Down at the River 87

7. Along the Tracks 95

8. Life in the Country 99

9. Cause for Celebration 119

ACKNOWLEDGMENTS

When I moved to Montgomery a few years ago, one of the first places I visited was the Montgomery library. When I found it—smack dab in the center of town—it was apparent that someone thought that the history of Montgomery was very important. I returned to the library when I was deciding whether to go ahead with this project and was amazed at the sheer volume of historical materials that the library had accumulated. This book was just waiting for someone to put it together!

From the very beginning, I was encouraged by the overwhelming enthusiasm and cooperation of everyone I contacted, especially the members of the Montgomery Area Historical Society. One person I must thank first of all is Marion Decker McCormick, who went far beyond what I expected of her and I was surprised many times when she came up with that elusive bit of information or the name of the person who could answer a particular question. She is a valuable resource that Montgomery is lucky to have. I also want to thank Sue Thomas, Cynthia Bryan, and Carrie Blain for your trust in my care and safe return of invaluable library materials. Also, thank you to Edmund Shollenberger for your gift of photographs to the Montgomery Area Historical Society and the Montgomery Area Public Library, as well as all others who have donated materials that are now found in the library's historical collection.

You may be as close as my neighbors across the street, or as far away as Thailand—but you have all played an important role in the successful completion of this project. Thanks to all: Kevin Bailey, Janet Bennett, Galen Betzer, Hugh Christie, Pat and Donna Deitrick, Jack Devitt, Bill Devitt, Allen and Gay DiMarco, Lynn Ditty, Edna Fox, Donald and Carol Gresh, June Grube, Vincent Hall, Allen Horn, Don and Joan Hoover, Carl Jarrett, David Johnson, police chief Terry Lynn, James Maust, Keith and Leona McCormick, Paul Metzger, David Morehart, Melanie Eddinger Norton, Fred and Susan Pfeiffer, Harvena Richter, Bob and Jane Russell, Doug and Renee Snyder, Harold and June Snyder, Becky Sanguedolce, Eleanor Taylor, Genevieve Voneida, Robert and Lois Warner, Lanny and Sharon Wertz, police sergeant Larry Wilcox, and Peggy Yohn. To my editor at Arcadia, Erin Vosgien, thank you for your expert guidance. And, finally, I want to thank my family for your support and understanding during this past year.

INTRODUCTION

Former newspaper editor and local historian John F. Meginness wrote the *History of Lycoming County Pennsylvania* in 1892. Although Meginness's historical account of the area included a comprehensive listing of the people, places, and events in the county over a period of 200 years, the author's descriptions of the communities illustrated his journalistic tendencies. In his opening paragraph for the chapter about Montgomery, he wrote:

> There is much bold and beautiful natural scenery in easy view from the borough of Montgomery. Just across the river rears that abrupt range known as Muncy Hills, which has figured in history from the time of the advent of the first white men in this valley; and within their dark and hidden recesses many strange and startling scenes have been enacted. On the west side of the borough line the escarpment of Penny Hill is presented, with its craggy face and overhanging cliffs, covered with stunted foliage and ferns in summer time, and glittering icicles when the frost king reigns.

Paints quite a picture, doesn't it? Strange and startling scenes? Yes, it's true. Montgomery has a colorful history—full of adventure and excitement, tragedy and sadness. These contrasts seem to have always been a part of Montgomery including the names of its location between Black Hole Valley and White Deer Valley.

This area, which now includes the borough of Montgomery, as well as Brady, Clinton, and Washington Townships in Lycoming County, and a portion of Gregg Township in Union County, were once in Northumberland County. Boundaries shifted and merged over the years, but the communities that formed remained constant. The first pioneers in the valley were primarily farmers who built mills—gristmills, sawmills, wool carding mills—and distilleries. Life was hard. Native Americans continued to raid settlers' homes. Diseases and natural disasters claimed lives. Still there were those who pushed westward to find land and a place to call home.

From what can be determined from historical accounts, the first resident of the Montgomery area was Cornelius Lowe. He and his family settled near the Susquehanna River in the vicinity of Broad Street in Montgomery around 1771 but soon abandoned their cabin because of Native American uprisings. Severe weather during the winter of 1787 and spring flooding in 1788 tested the character of the remaining settlers, but they endured. Churches were established—the first in the area was the Washington Presbyterian Church in White Deer Valley, sometime in the 1790s. Before the first schools were built, teachers traveled throughout the valley, educating

the children in their homes. Communities grew and came to be known as Clintonville, Maple Hill, Elimsport, Alvira, Texas, Spring Garden, and Guise Town.

In this book, you will find a variety of scenes taken from postcards and photographs, which were all produced before 1940 and represent a time when ladies' skirts were long and the work day was even longer. It does not matter if you are new in town or if your great-grandfather worked in the Montgomery Table Works factory, you will be surprised at the places that seem familiar to you.

The first chapter of borough streets and homes takes you on a tour of Montgomery during the early 1900s when the roads were muddy and the houses on Houston Avenue were brand new. You will see the Decker mansion under construction and the row house known as the "Terrace Block." And that stone wall along Montgomery Street? Yes, it has been around for almost 100 years!

The second chapter is where you will find some of the most interesting stories about the people and places around town. You will find out about the "Klondikers" who searched for gold in Alaska, the Clinton Township native who had a band named for him, the teenager who grew up to win a Pulitzer Prize, the reason Montgomery had two locations for its fire equipment, and the tragic stories of senseless murders both on the streets of town and in the rural countryside.

Within the next few chapters, can you find the familiar faces of your grandparents or their parents? Classes of schoolchildren with their teachers, names, dates, and interesting tidbits of information fill a dozen pages while vintage images of area church buildings and the history of their congregations follow.

Then you will see the backbone of Montgomery—its industrial legacy that began with the establishment of the Henderson planing mill in 1869. Thus began the steady influx of wood-related manufacturing companies including the American Wood Working Machine Company, the Montgomery Lounge Company, the Penn Furniture Manufacturing Company, the Montgomery Table Works, and many more. And then there is always playtime after a long day at work! Take a look at what the residents of Montgomery did for recreation. The Susquehanna River and the railroads were also important to those who lived in town. Until the bridge was built in the 1920s, a ferry was used to get from one side of the river to the other. Check out the scenes of flooding, the railroad stations, and more.

And what about the residents of those communities in the outlying areas? The chapter Life in the Country illustrates life in the rural communities surrounding Montgomery in Washington, Brady, and Clinton Townships, as well as Gregg Township in Union County. You will find rare scenes of Devitt's Camp, Alvira before its demise, and the Devil's Turnip Patch. And, in closing, you will see how Montgomery has observed a variety of events during its first 50 years, ending with its week-long semicentennial celebration in 1937. Welcome to Montgomery!

One

BOROUGH STREETS
AND HOMES

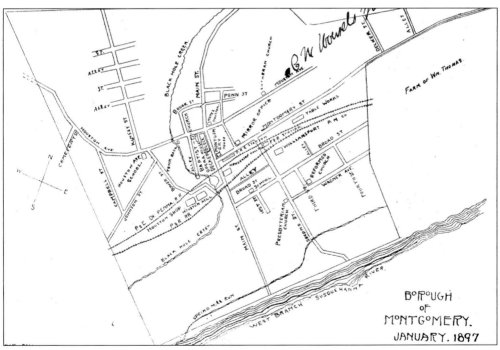

This detailed map of downtown Montgomery was printed in the 1897 edition of *Grady's Directory*, which included a listing of the names and addresses of over 400 Montgomery residents and businesses, as well as a directory of streets, maps, county and borough government departments and officers, and an assortment of business advertisements. The *Grady's Directory* was published by Thomas E. Grady, the editor and publisher of the borough's newspaper, the *Montgomery Mirror*. (Courtesy of the Montgomery Area Historical Society.)

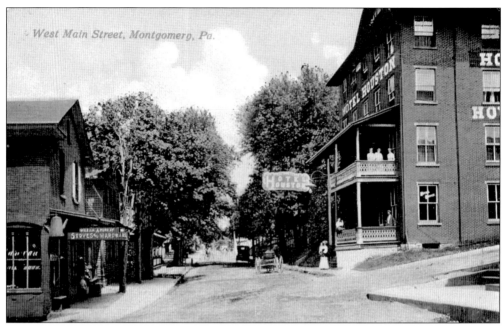

At the center of town stood the Hotel Houston (see also page 24) on the eastern corner of Main Street and Houston Avenue, across from the stove and hardware store run by William A. Murray. The large coffee pot hanging on the corner of Murray's store appears in many of the printed postcard images of this intersection. (Courtesy of Marion McCormick.)

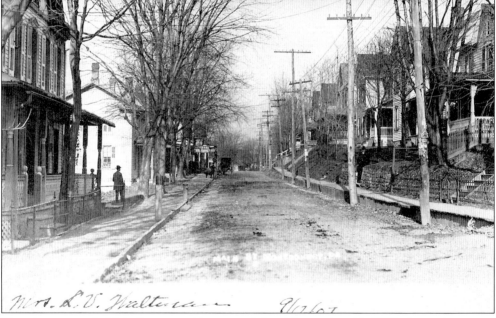

The view up north Main Street on this postcard dated September 12, 1907, shows the row of poles that held the wires bringing electricity into town. It was during December 1897, when the Montgomery Electric Light and Power Company was formed. Heading up this progressive organization were William Decker, who served as president, vice president D. W. Shollenberger, and Scudder Shoemaker, acting as secretary. (Courtesy of Marion McCormick.)

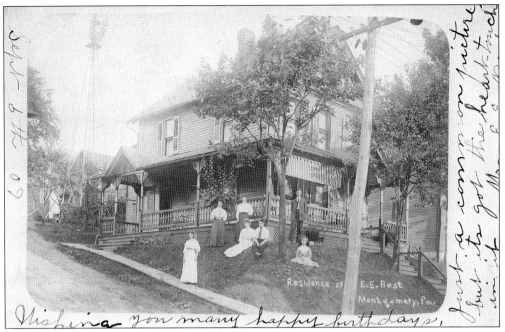

In 1909, Susan Best sent this postcard with the following sentiment: "Wishing you many happy birthdays. Just a common picture, but it's got the heart-touch in it. [signed] Mrs. E.E. Best." At that time, she lived in this home on North Main Street with her family, which included her husband, Elmer E., her daughters, Myrtle and Caroline, and a son, Palmer. (Courtesy of Marion McCormick.)

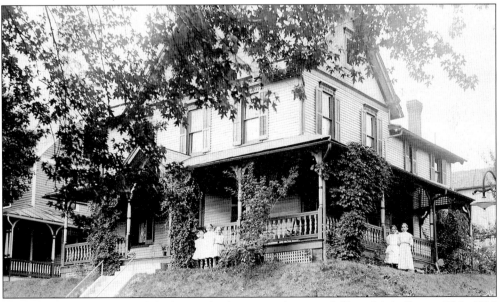

Pictured here is another of the homes built against the steep hill on Main Street. This 1908 postcard image shows the home of Howard Abner Schnee and his wife, Ella, who were the parents of a son, Ralph, and three daughters. Although the five girls here are not identified, it is known that the three Schnee girls were aged 16, 13, and 7 in 1908. (Courtesy of the Montgomery Area Public Library.)

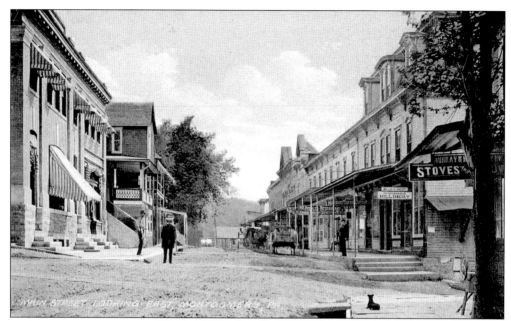

In this view of south Main Street, from the corner of Main and Houston Avenue, the millinery shop owned and operated by Susan Best (see previous page) can be seen on the right, just across the street from the Murray stove and hardware store. The roofs built over the front entrances of many stores were removed in 1923 during a remodeling project on Main Street. (Courtesy of James Maust.)

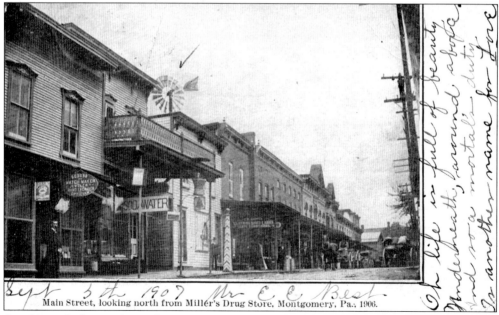

Main Street, looking north from Miller's Drug Store, Montgomery, Pa.; 1906.

On this card, the jewelry and optical store operated by B. D. Bubb is seen in the foreground, with the Miller Drug Store next door, and a windmill at the rear of the buildings. Written on the side, another poetic sentiment by Susan Best is penned: "Oh life is full of beauty, underneath, around, above. And so a mortal's duty, is another name for Love." (Courtesy of the Montgomery Area Public Library.)

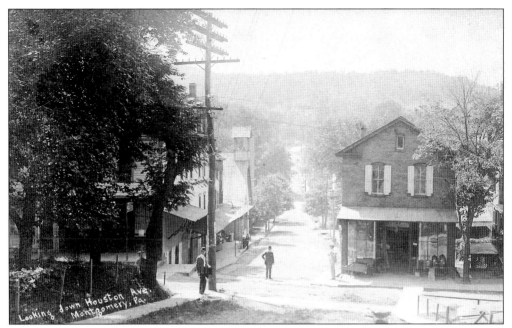

One of the steepest hills in town is on Houston Avenue where it crosses Main Street. In this view, the front of the hardware store that had been originally run by David Love stands on the corner with the tall steeple of the Baptist church appearing on the left. Love retired in January 1904 and the business was taken over by William Murray. (Courtesy of Peggy Yohn.)

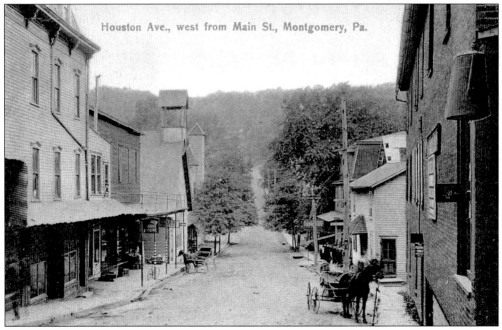

Look closely in the upper right-hand corner of this postcard and the coffee pot hanging on the corner of Love's hardware can be seen. Zeller's Furniture and Undertaking is located on the right, as West Houston Avenue dips down and then ascends on its way out to Pinchtown Road. (Courtesy of Lynn Ditty.)

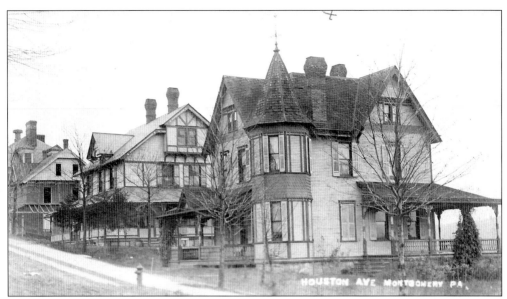

This Victorian-style home was built on East Houston Avenue during the mid-1880s over a three-year period. Its front lawn, which extends down the hill to Montgomery Street, was eventually landscaped to become one of the most picturesque terraced lawns on the street. Members of the Waltman family lived here, who were reportedly involved with the early manufacturing of automobile engines. Next door is the Shollenberger house (see below). (Courtesy of Lynn Ditty.)

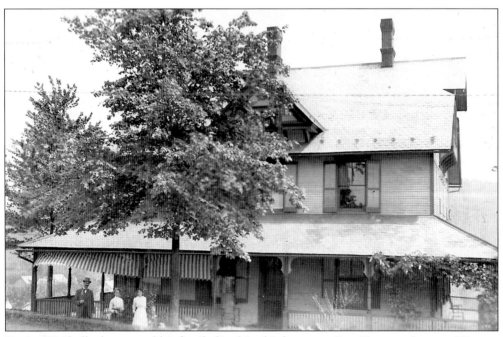

Darius W. Shollenberger and his family lived in this house on East Houston Avenue. His son, Edmund Kennard, took this photograph, one of hundreds he took of scenes in the borough during the 1930s. A number of his photographs have been reprinted in this book; for a look at E. K. Shollenberger himself, please turn to page 90. (Photograph by E. K. Shollenberger, courtesy of the Montgomery Area Historical Society.)

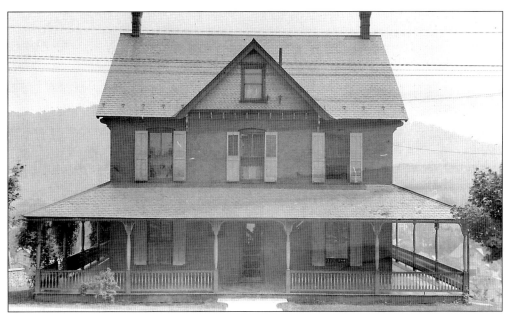

When this photograph was taken in 1937, this was the East Houston Avenue home of George Lester and Ruth Hartranth. George's father was Philip F. Hartranth, who had come to Montgomery in 1887 to establish its first insurance agency. The Hartranft-Henderson Insurance Company helped the residents withstand a variety of catastrophes by supplying insurance protection against their losses. (Photograph by E. K. Shollenberger, courtesy of the Montgomery Area Historical Society.)

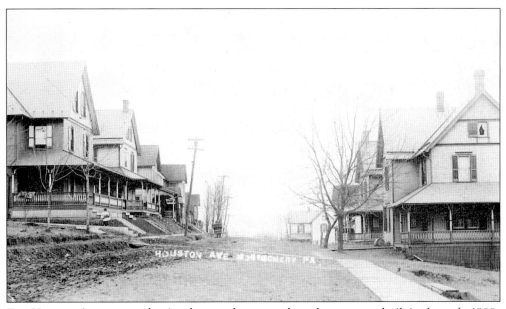

East Houston Avenue was the site chosen when many large homes were built in the early 1900s because of its elevated location above Montgomery Street and the industrial factories below and views of the Susquehanna River to the south and east. Many of these century-old homes are still standing and are lovingly maintained by their current owners. (Courtesy of Fred Pfeiffer.)

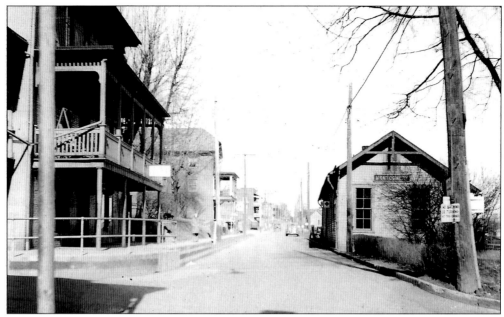

Photographed on March 7, 1937, this image offers a view of Montgomery Street from the corner of Main Street with the Montgomery Hotel on the left and the railroad station on the right. The sign on the pole near the station cautions drivers that backing up and turning around at this corner would be ill-advised. (Photograph by E. K. Shollenberger, courtesy of the Montgomery Area Historical Society.)

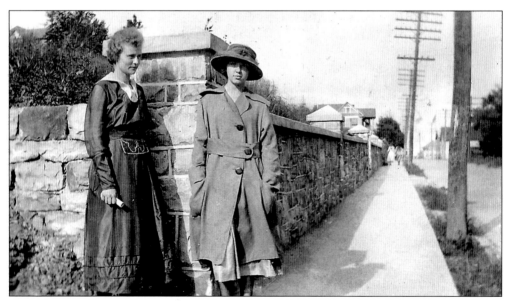

Lois Dunn (left) and Eva Phillips are seen here at the corner of a newly constructed stone wall that still extends down a large portion of Montgomery Street. The wall and cement walk were built in 1918 by order of the Montgomery School Board to run along the school property at the bottom of the hill below the East Houston Avenue school building. (Courtesy of Eleanor Taylor.)

The row of houses seen behind Eva Phillips (left) and Lois Dunn was known as "the Terrace." This multihome building was built by J. E. Heilman across from the new Penn Manufacturing Company office building on Montgomery Street, where Dunn and Phillips worked around 1918. Although the Terrace Block has since been demolished, the stairs that once led up to the porches still remain. (Courtesy of Eleanor Taylor.)

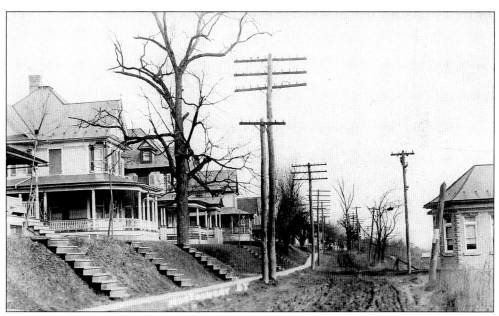

When Main and Montgomery Streets were paved with bricks in June 1914, it eliminated the muddy streets and rutted paths that often became quite difficult to navigate, as seen here in this view of Montgomery Street. At the right, the Penn Manufacturing office building is seen; for a close-up view of this building, please see page 75. (Courtesy of Edward Miller.)

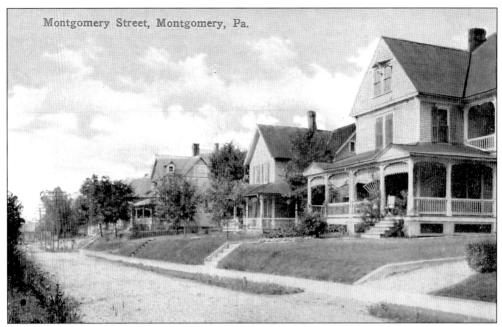

The house pictured on the right was located on the Decker property on Montgomery Street. In 1907, the house was moved by horses and block and tackle to its present location at 116 East Houston Avenue. The Decker house was built within a few years (see next page). (Courtesy of Sharon and Lanny Wertz.)

This unusual home, built of rubble stone, was built sometime before 1920 on the south side of Montgomery Street. Behind the house near the railroad tracks was the Montgomery Lounge Company building, which could be accessed from Montgomery Street via an elevated wooden walkway (see page 73). (Courtesy of the Lycoming County Historical Society and Thomas Taber Museum.)

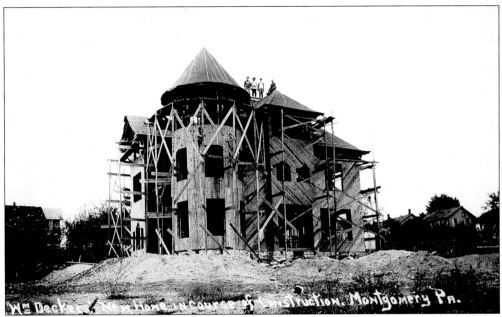

The William Decker home, also known as "the mansion" on Montgomery Street, has a grand view of the industrial section of town, where Decker's furniture business, Montgomery Table Works, employed a large workforce. Shown here is a rare view of this 1910-era home during the time of its construction. For more information about the house, please turn to page 42. (Courtesy of Lynn Ditty.)

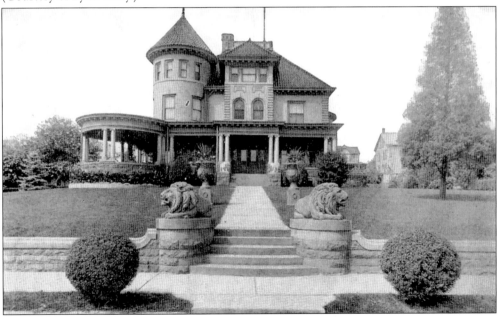

Although they were considered one of the wealthiest families of Montgomery, the Deckers were not immune to tragedy. William was killed in 1924 by the freight elevator in his own factory four years after his 24-year-old daughter died of influenza, weeks before her wedding. Both are buried in Fairview Cemetery outside of town in the Decker mausoleum, where a smaller pair of lions stand guard nearby. (Courtesy of Marion McCormick.)

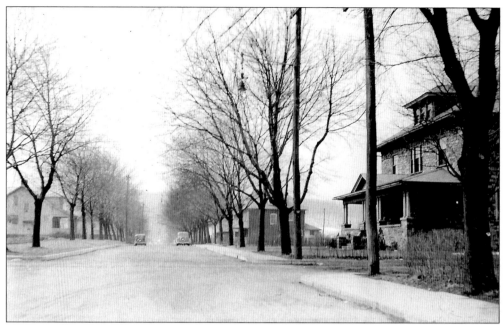

This photograph of Penn Street was taken by E. K. Shollenberger about the time of the new Montgomery public school's construction in 1930. The school is located on the eastern end of this street. (Photograph by E. K. Shollenberger, courtesy of the Montgomery Area Historical Society.)

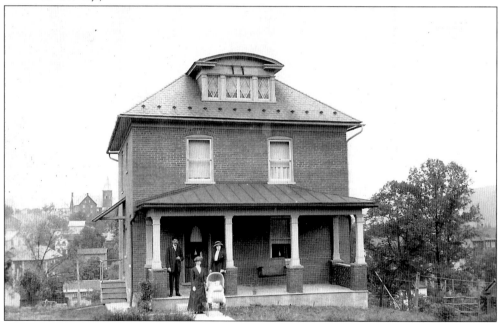

In this photograph taken about 1913, E. K. Shollenberger captured the image of his parents, his wife, Clara, and his baby son, Darius, in the carriage in front of their home on Kinsey Street. In the background, to the left of the house, the spire of the Lutheran church on East Houston Avenue can be seen. (Photograph by E. K. Shollenberger, courtesy of the Montgomery Area Historical Society.)

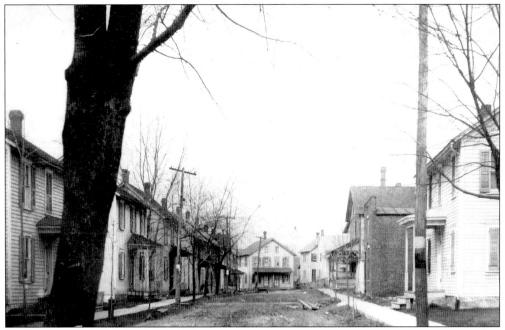

Brook Street doglegs behind the northwest corner of Main Street connecting with West Houston Avenue. Close in proximity to the downtown businesses, Brook Street is also near Black Hole Creek, which causes frequent flooding to this street. No one was prepared for the June flood of 1889, however. The *Montgomery Mirror Extra* published on June 1 stated, "Black Hole creek has turned into a large rapid river and is sweeping everything in its way . . . the livery stable is taking a bath and is in water up to its chin." Fortunately, no loss of life was reportedly caused by this catastrophe. (Above, courtesy of the Montgomery Area Public Library; below, courtesy of Hugh Christie.)

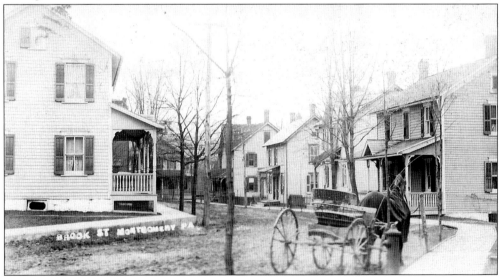

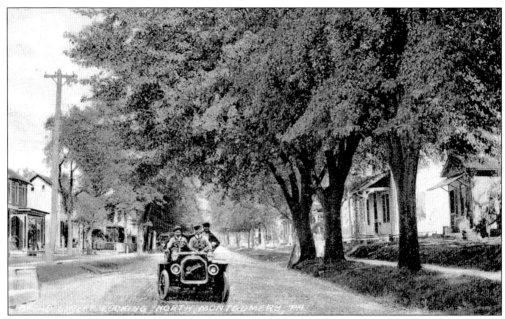

In 1899, the first horseless carriage reportedly appeared on the streets of Montgomery and this adventurous trio coming down Broad Street seem to be enjoying the newfangled mode of transportation. There is a tale, however, of a Montgomery businessman, Sumner Leonard, who never learned to drive his brand-new automobile; his wife was the one who drove him to work and picked him up at the end of the day. (Courtesy of Lynn Ditty.)

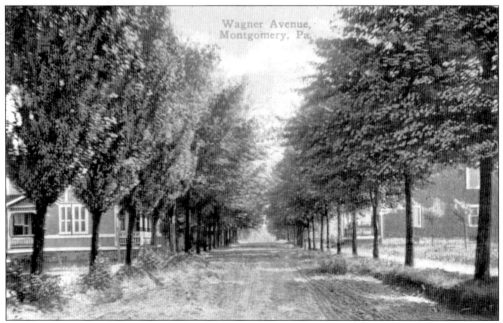

Although Wagner Avenue is located near the Susquehanna River, it rarely experienced flooding due to its slight elevation. When river levels rose, homes on Wagner Avenue would be evacuated because the area would be surrounded by water. For scenes of flooding in Montgomery, please turn to page 93. (Courtesy of Frank and Arlene Keller.)

Two

PEOPLE AND PLACES

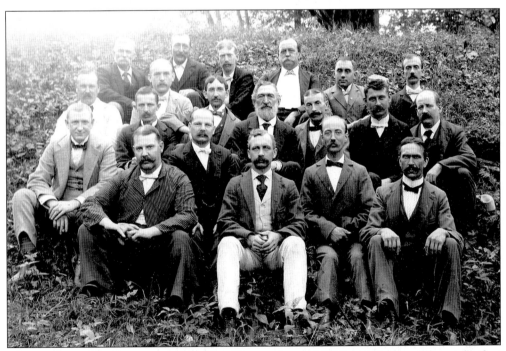

The members of the Montgomery Merchants Bureau (around 1895) include from left to right (first row) Edward Helmboldt, general store; David L. Love, hardware; George P. Hafer, general store; and George Decker, hardware and groceries; (second row) Oliver H. Hilliard, tailor; Calvin L. Housel, music store; and William M. Baker, music store; (third row) Sumner Leonard, general store; David Throne, men's clothing; Alvin C. Kilmer general store; Henry Decker, builder; Harry Thomas, news stand; Edward Strouse, novelty store; and John Derr, ice cream and candy; (fourth row) Samuel M. Zellers, undertaker; John Webb, meat shop; William Everett, jewelry store; Col. L. Kinsey, flour mill; Clinton L. Zellers, furniture store; and William E. Kilmer, general store. (Courtesy of the Montgomery Area Public Library.)

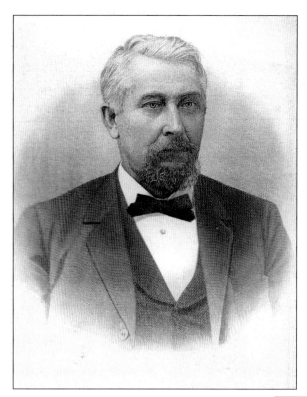

Levi Houston was not a Montgomery native but he was instrumental in the development of the town during its formative years. Houston came from New Hampshire in 1873 to manage a foundry and machine shop, which eventually became the Levi Houston Branch of the American Wood Working Machine Company. When he died in July 1892, his loss was felt throughout the community. (Courtesy of the Montgomery Area Historical Society.)

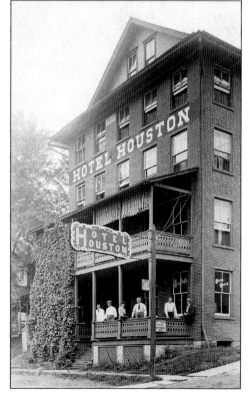

The grand opening of the Hotel Houston took place in May 1891 only a year before the death of Levi Houston, the hotel's owner. Built five stories high, the hotel featured comfortable steam heat throughout its 42 rooms and views of the Montgomery hills from the two piazzas across the front of the building. When the first electric lighted sign in town was placed on the front of the hotel on July 8, 1910, it caused quite a curiosity. (Courtesy of Marion McCormick.)

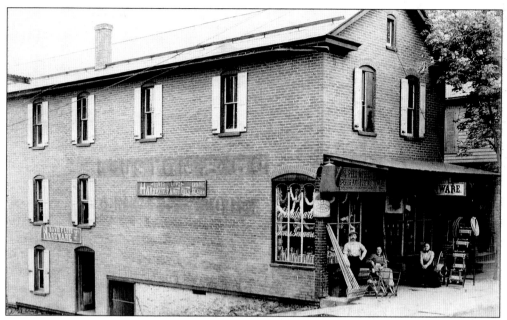

In January 1904, David L. Love retired from the hardware business after operating his store for 26 years. He was a member of the first borough council and was elected burgess in 1893, serving for four years. When the borough council had no permanent meeting place, Love offered the nail kegs in his tin shop to serve as seats for council members. (Courtesy of the Montgomery Area Public Library.)

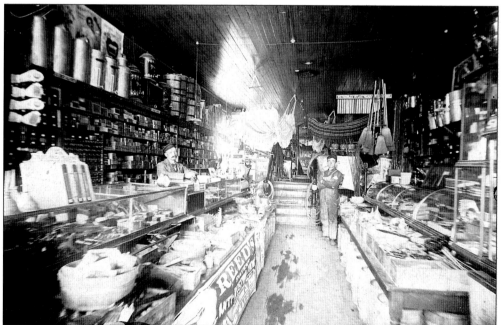

Buckets, brooms, barrels, hammocks, hoses, milk cans, and small boxes filled with nuts, screws, and assorted do-dads are just a few of the items that filled the Love Hardware store at the corner of Main Street and Houston Avenue. Love is seen on the left, behind the counter, with an unidentified customer around 1900. (Courtesy of the Montgomery Area Public Library.)

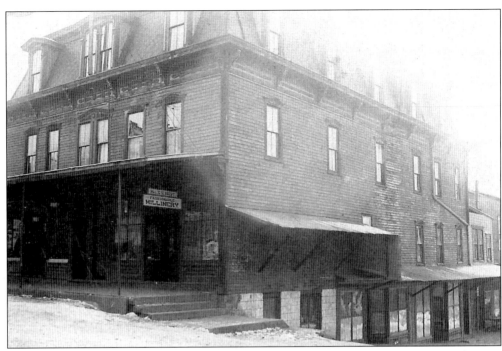

The building (above) at the corner of Main Street and Houston Avenue was part of what was called the Decker Block and housed one of the oldest mercantile businesses in town. In 1923, it was demolished to provide a prime location for the new First National Bank building. Organized in 1900, the bank was first housed in a one-story brick building erected next to Hafer's grocery store on Main Street. A board of directors elected officers: president was Hervey Smith, vice president was William Decker, and secretary was D. W. Shollenberger. When the bank opened its doors in November 1900, its capital was $30,000. By early 1924, the new bank building (below) was ready to open. The bank maintained its financial stability throughout the stock market crash in 1929 and during the Depression years following. (Courtesy of the Montgomery Area Historical Society.)

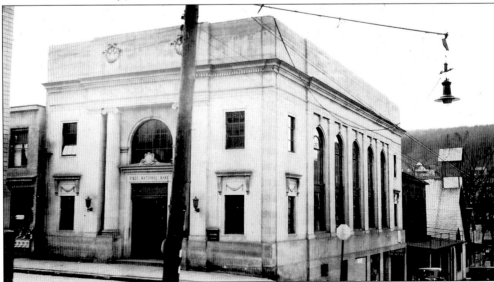

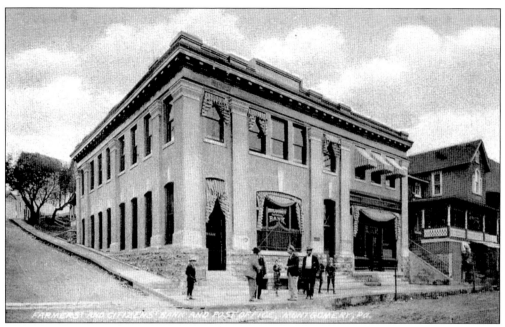

The Farmers and Citizens National Bank, located on the southeast corner of Main Street and Houston Avenue, featured a weekly deposit pickup service. The bank's young teller would travel by horse-drawn wagon between Montgomery and Allenwood to pick up deposits and deliver cash when requested. Who was this young man? He would grow up to become a Pulitzer Prize–winning author named Conrad Richter. (Courtesy of the Montgomery Area Public Library.)

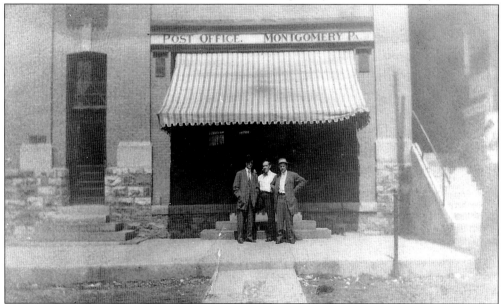

Montgomery's first post office was established in 1836 and was called Black Hole. In 1853, it was changed to Clinton Mills, and in 1860, it became Montgomery Station. Even though the borough was named Montgomery at its incorporation in 1887, the post office continued to be known as Montgomery Station. In 1894, the word *station* was officially removed from the post office address. (Courtesy of Edward Miller.)

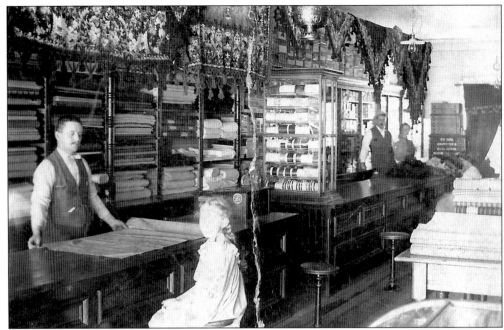

The Hughes Department Store on Main Street was operated by Harry Hughes (pictured above with his daughter, Marion) and provided fabric, ribbon, spools of thread, and other items necessary for the housewife to make dresses for her daughters and aprons for herself. In the March 25, 1898, edition of the *Montgomery Mirror*, Hughes advertised "good towling [*sic*] 5 cents a yard." Groceries, shoes, and china were also available as well as complimentary wagon delivery service. In the photograph below, Harry is standing in the shadows of his store's doorway while his employees pose in front. Pictured from left to right are Irving Wahlize, Ruth Stugart, Elsie Fague, and Florence Hall with three unknown gentlemen. (Above, courtesy of the Montgomery Area Public Library; below, courtesy of Marion McCormick.)

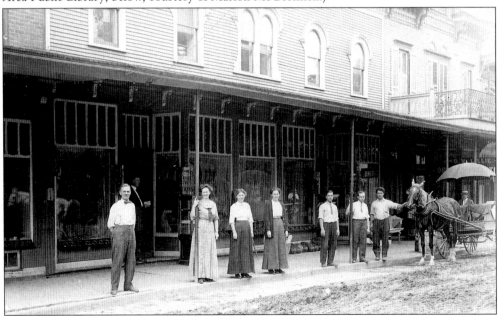

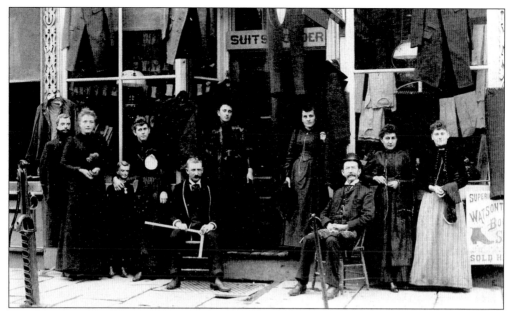

O. H. Hilliard operated his "Merchant Tailor, Clothier, and Gent's Furnisher" shop on Main Street. This pre-1910 photograph shows Hilliard and his staff posing with a couple of the store dummies. From left to right are a big dummy, Carrie Hain, a little dummy, May Hughes Pfaff, O. H. Hilliard (seated), Mertle Butler, Mary Derr, Pete Zimmerman (seated), Maggie Searph, and Else Welshans. (Courtesy of the Montgomery Area Public Library.)

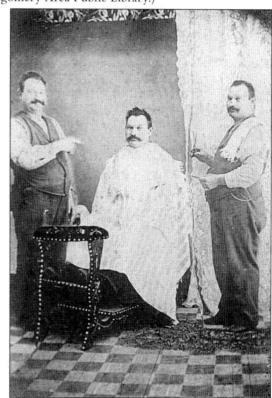

W. S. Rice, the resident barber who had a shop across from the Hotel Montgomery at the south end of Main Street, advertised his services in 1897 as the town's "tonsorial artist" in haircutting, shaving, shampooing, and trimming. This triple exposure features Rice as barber, customer, and critical observer. (Courtesy of the Montgomery Area Public Library.)

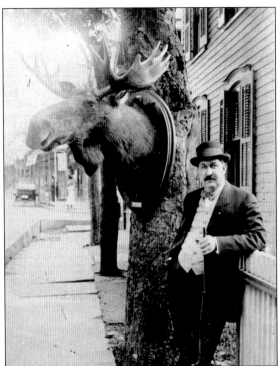

It is unknown whether the stuffed and mounted moose head was a permanent display outside Dr. John Frank Gordner's office on Main Street. Whatever the reason, this amusing scene is now captured for posterity as part of Montgomery's history. Gordner served the medical needs of the community from his office on Main Street. (Courtesy of the Montgomery Area Public Library.)

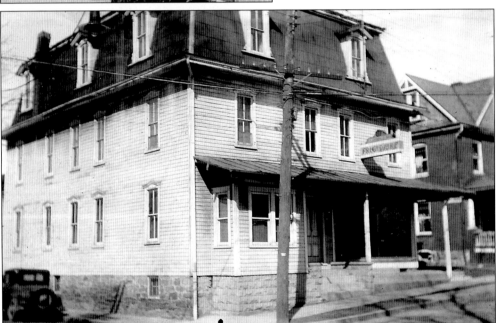

Following the practice of many undertakers of the late 1800s, Samuel L. Zellers also operated a retail furniture store, seen here during the 1930s. Opening in early March 1887, just a few weeks before the borough was incorporated, Zellers eventually went into partnership with his son. In 1896, Zellers installed a water sprinkler system in the store after fires destroyed a number of local businesses. (Photograph by E. K. Shollenberger, courtesy of the Montgomery Area Historical Society.)

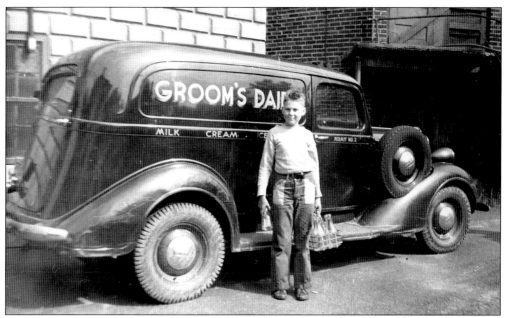

When Montgomery celebrated its 50th year of incorporation in 1937, Groom's Ice Cream was advertising its diner located on the Montgomery Pike. This was the place to stop for homemade ice cream, milk shakes, sandwiches, and soft drinks. Ivan Groom also owned and operated an ice-cream store in town, which was the place to hang out after a movie. His ice-cream manufacturing business was headquartered on Brook Street, behind the theater. Although the boy posing in front of the Groom's Dairy delivery sedan is not identified, he most certainly enjoyed his share of Groom's frozen treats. The young lady (below) waiting to take orders in the ice-cream shop is identified as Dorothy Shelley, who was also hired as a first-grade teacher for the Montgomery School District for the 1937–1938 school year. (Courtesy of June Grube.)

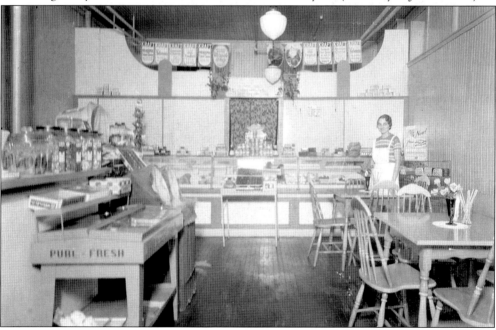

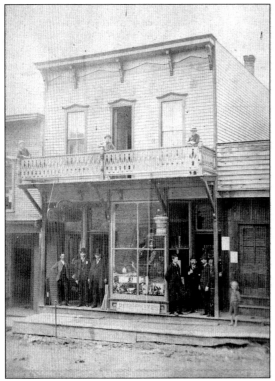

On September 14, 1886, the Miller's Drug Store opened its doors on South Main Street. The ownership of the business remained with the Miller family for almost 100 years, with John Miller's son Paul and grandson Rupert minding the store until it was sold in 1983. Shown at left is a group of Montgomery's most prominent businessmen standing in front of Miller's Drug in 1888. They are, from left to right, John L. Miller, D. W. Shollenberger, Levi Houston, Harry Hess, Alfred Burley, and Aaron Koons. The child on the right is Harry Derr. Above them on the porch are O. J. Housel, David Koons, and Edward Burley. Below is a later photograph with members of the Miller family posing in front of the store. (Courtesy of Edward Miller.)

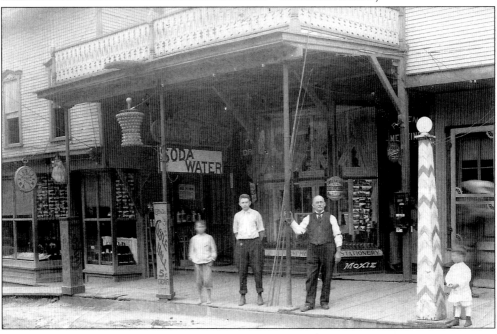

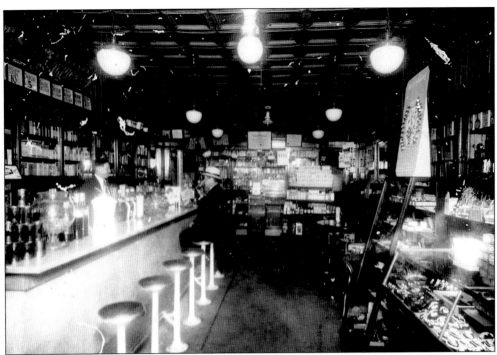

By 1923, John Miller's son Paul was conducting business behind the counter at Miller's Drug Store (above). On Sunday, January 26, 1930, tragedy struck the heart of downtown Montgomery when a fire spread throughout the business section of Main Street. In addition to Miller's Drug Store (seen at right, after the fire), Love's Radio and Shoe Repair, John's Cigar Store and Billiard Room, the dental offices of Dr. H. R. McCall, and the A&P store, as well as several apartments, were damaged or destroyed. Temperatures that day were near zero, which caused ice to form almost immediately on all surfaces, making it a difficult fire to fight. Nearly all affected businesses reopened quickly in makeshift quarters until permanent space was acquired. (Courtesy of Edward Miller.)

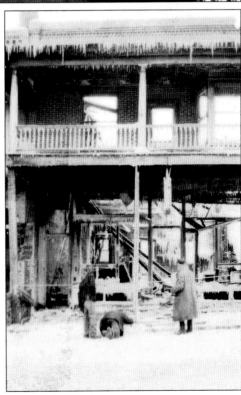

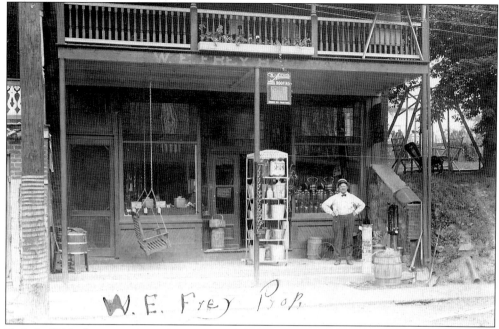

Early in 1902, the W. E. Frey Plumbing and Heating store opened for business. In August 1913, the first gasoline pump in town was installed in front of the store. This was a great convenience to residents who owned an automobile; previously, they had to drive to Muncy to fill up their car's gas tank. (Courtesy of the Montgomery Area Public Library.)

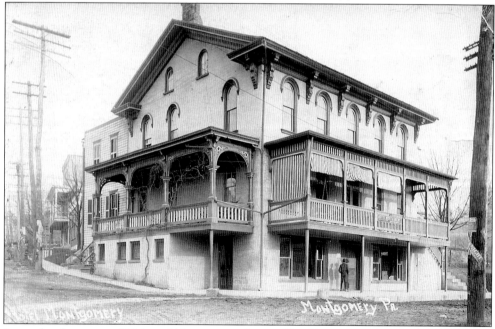

Located at the corner of Main and Montgomery Streets, Hotel Montgomery was built in the 1860s by the town's namesake, Robert Montgomery. During the 1889 flood that ravaged the borough, it has been said that the daughters of Aaron Koons, the hotel's proprietor, served sandwiches from the hotel windows to the men who were patrolling in boats. (Courtesy of Galen Betzer.)

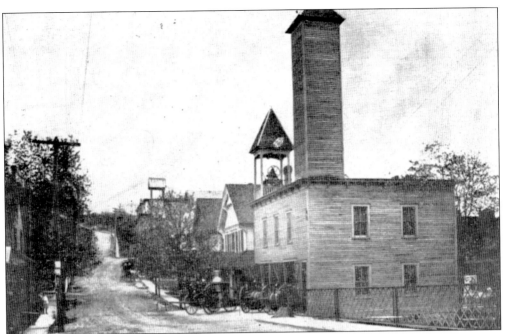

In 1892, after two fires destroyed several of Montgomery's major businesses, the first fire company was organized, with the borough hall building on West Houston Avenue (above) serving as the primary fire station. The tall tower was used to hang the fire hoses until they were dry. Below is a group of Montgomery's early firefighters in 1899. From left to right are (first row) Thomas Grady, Charles Edward Strouse, Chester Wagner, William Waltman, Clinton Zellers, David F. Love, John Derr, Jerry Bruner, and Calvin Mackey. In the driver's seat is Benjamin Hartline with Nate Sterner standing behind the pumper, which replaced the first fire engine that was purchased secondhand in 1893. After several practice runs, it was determined that "Yellow Sal"—so named because it was made of bright yellow brass—was not reliable and returned. (Above, courtesy of Lynn Ditty; below, courtesy of the Montgomery Area Public Library.)

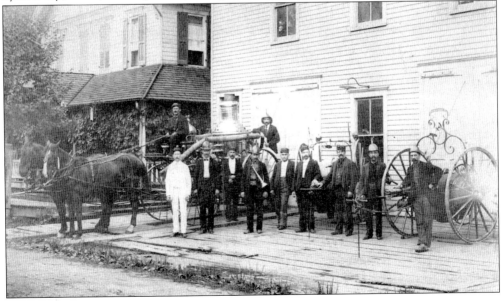

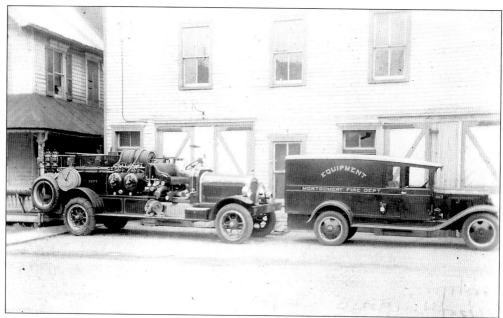

In the photograph pictured above, which was taken in 1937, the 1930s-era equipment is seen parked in front of the fire station building on West Houston Avenue. In 1930, the Montgomery Volunteer Fire Company received a new combination hose and chemical truck, which was housed in the newly erected building on Second Street (below). This additional equipment at another location provided protection for residents on the south side of town in the event that trains that were on the tracks at the time of a fire could delay the fire trucks, which were garaged on West Houston Avenue, across the tracks and on the other side of town. (Photographs by E. K. Shollenberger, courtesy of the Montgomery Area Historical Society.)

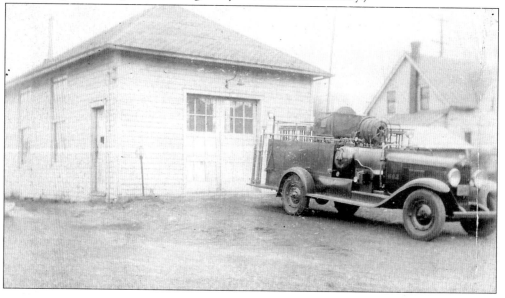

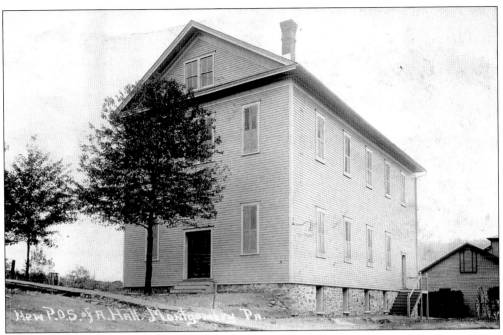

The local society of Patriotic Order Sons of America (POS of A) was organized in Montgomery on the day before Christmas 1887. Above is the camp's new POS of A hall located on East Houston Avenue, built near Main Street. By the 1930s, the building was used by the Montgomery Council 51 Junior Order of United American Mechanics (OUAM). (Courtesy of Hugh Christie.)

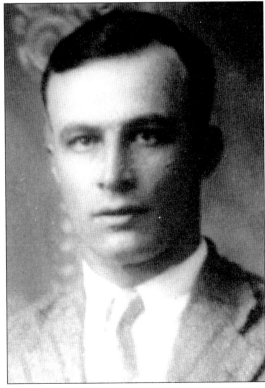

On December 13, 1938, the police chief of Montgomery, 36-year-old Henry S. Hand, was a victim of a random crime as he walked along Houston Avenue at 10:30 a.m. He was gunned down by two shotgun blasts and quickly succumbed to his injuries. The shooter, William L. Andrews, was taken into custody and confessed to the crime, saying that he held a grudge against people in uniform. (Courtesy of the Borough of Montgomery Police Department.)

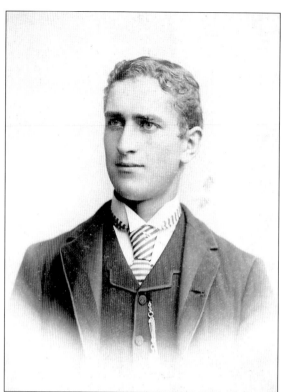

"Klondike or Bust" shouted the headline in an 1898 edition of the *Montgomery Mirror.* Twenty-seven-year-old Benjamin Franklin (Frank) Decker was the leader of a group of seven men from the Montgomery area who left to seek their fortunes in the Alaskan gold mines that year. Most of the "Klondikers" returned with only a handful of nuggets or gold-streaked quartz, while Decker continued his search in California. (Courtesy of Marion McCormick.)

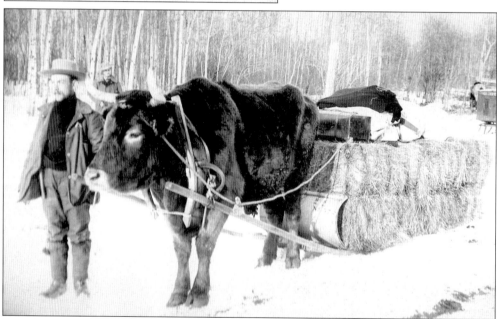

Friends and family back home in Montgomery were able to track the progress of the Klondikers by reading portions of letters written home, which were printed in the *Montgomery Mirror.* Decker's nephew and fellow member of the group, Alonzo High, wrote home, "We are on our way with five oxen [pulling] five tons of grub . . . what seems to me to be an awful lot of provision." (Courtesy of the Montgomery Area Public Library.)

Born in Clinton Township in 1813, Daniel Repasz lived in Muncy, became a tailor, and learned to play the violin. When he was 25 years old, he moved to Williamsport to teach music and dancing. He joined the Williamsport Band in 1840, playing key bugle. He became its director 1856, and in 1859, the band was renamed the Repasz Band in his honor. (Courtesy of the Repasz Band.)

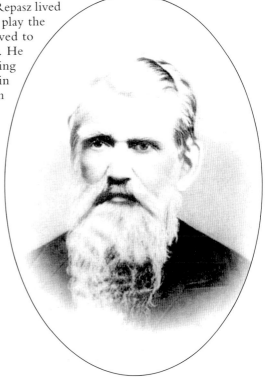

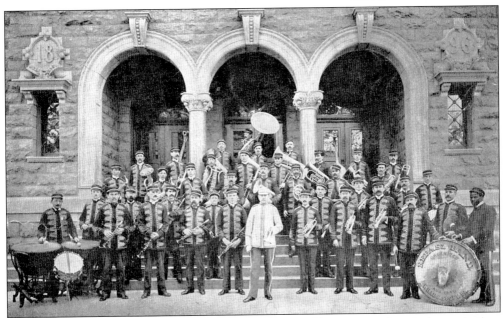

The Repasz Band, pictured here around 1901, became one of the most noted musical organizations in the eastern United States in the 19th century. "The Repasz Band March," composed by Harry J. Lincoln in 1896, became a dance-hall two-step favorite during the early 1900s. Although Daniel Repasz died in 1891, his portrait continued to be displayed on the band's bass drum after his death. (Courtesy of the Repasz Band.)

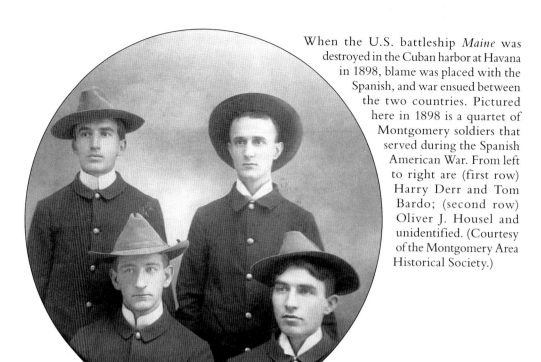

When the U.S. battleship *Maine* was destroyed in the Cuban harbor at Havana in 1898, blame was placed with the Spanish, and war ensued between the two countries. Pictured here in 1898 is a quartet of Montgomery soldiers that served during the Spanish American War. From left to right are (first row) Harry Derr and Tom Bardo; (second row) Oliver J. Housel and unidentified. (Courtesy of the Montgomery Area Historical Society.)

In October 1892, the local post of the Grand Army of the Republic (GAR), Col. D. L. Montgomery Post No. 264, presented the Sailors and Soldiers Monument to the citizens of Montgomery and placed it in the Fairview Cemetery. The GAR post was comprised of those who had fought in the Civil War; almost 300 area men wore Union uniforms while a few chose to fight for the Confederates. (Courtesy of Vincent Hall.)

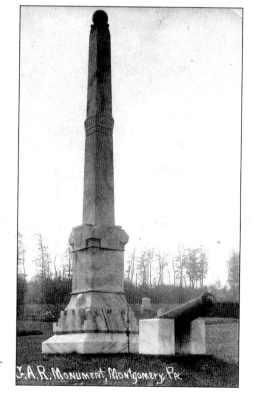

Freeman Bower was the first young man from Montgomery who died in World War I and was also the first to die in that war from Lycoming County. He enlisted on October 17, 1917, became a member of the U.S. Army Company F, Sixth Engineer Division, and went overseas in December 1917. Bower died on March 31, 1918, in France, where he was buried. The Montgomery American Legion was founded on August 11, 1919, and was named the Freeman W. Bower Post 251. (Courtesy of the Montgomery Area Historical Society.)

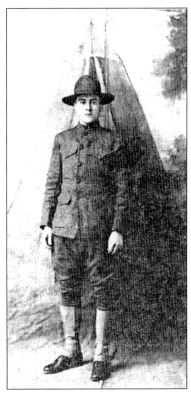

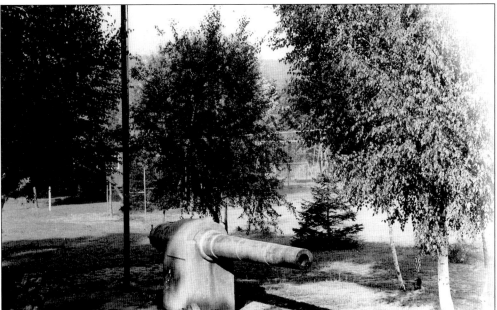

In 1927, a war memorial to the six World War I casualties from the Montgomery area was established in the park located along the river. The dedication of this memorial was made on November 11 of that year by the Legion Post No. 251. Plaques with each soldier's name and trees were chosen and placed in a circle around this cannon to honor the fallen soldiers. (Courtesy of the Montgomery Area Public Library.)

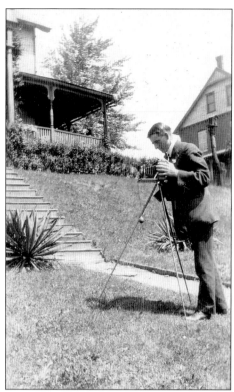

On a sunny day in May 1915, E. K. Shollenberger took this photograph of Warren Coy getting ready to take a photograph. The images found on many of the postcards produced during this era were taken with a camera such as the one Coy is using. The photographs would be printed on preprinted postcard-back paper, which were then mailed or saved in postcard albums. (Photograph by E. K. Shollenberger, courtesy of the Montgomery Area Historical Society.)

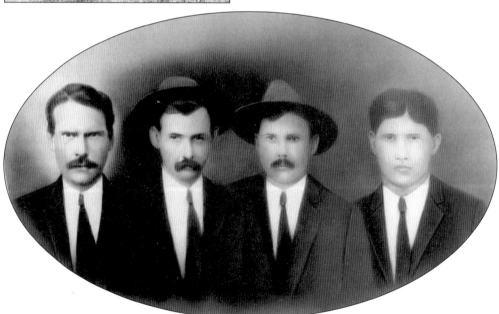

When William Decker's house was built around 1908 (see page 19), these four brothers were the wall plastering crew. They are, from left to right, Robert, John, Alfred, and Jake Phillips. While they were on the job, someone had stopped to take their portrait. After the brothers covered their work clothes with shirts, ties, and jackets that the photographer had in his wagon, the photograph was taken. (Courtesy of Janet Bennett.)

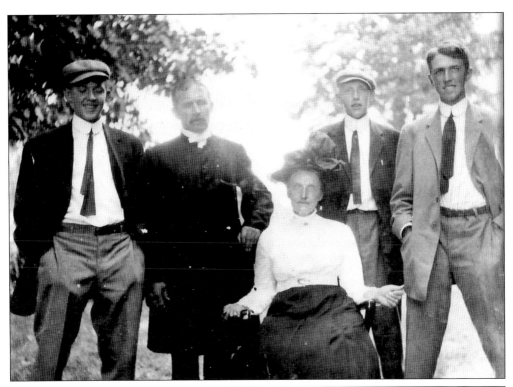

It was mentioned on page 27 that author Conrad Richter worked in the Farmers and Citizens National Bank in Montgomery when he was a teenager. His father was called to be the pastor of three churches in White Deer Valley between 1906 and 1910. Pictured above is the Richter family, from left to right, Conrad, his father and mother John and Charlotte (Lottie), and Conrad's younger brothers Joe and Fred. At right is a photograph of Conrad enjoying some fresh summer melon with his cousin, George "Shorty" Keely. In a letter Richter wrote in 1953 to the editor of the Muncy *Then and Now* magazine, he states that his family considered their "happiest days together were spent [in the Montgomery area]." Richter goes on to say, "The beautiful old valley of my youth . . . still shines in my heart and mind." (Courtesy of Harvena Richter.)

On Thursday, November 23, 1899, a grisly discovery was made near a haystack in a field outside Montgomery. Three bloodied and battered bodies wrapped in burlap were found—those of the former Sarah Delaney and two of her children, a nine-year-old boy and a five-year-old girl. Sarah's youngest child, a baby, was missing. The suspect was immediately identified as William Hummel, the man who had married Sarah less than a week before she and her children went missing. The house where the quadruple murders occurred is pictured above and was described by a local reporter as a "simple affair with four rooms" where blood was found on the walls and beds. Pictured below are the victims as they were depicted in the local weekly newspaper, the *Grit*. (Above, courtesy of Joan Hoover; below, courtesy of the James V. Brown Library Archives.)

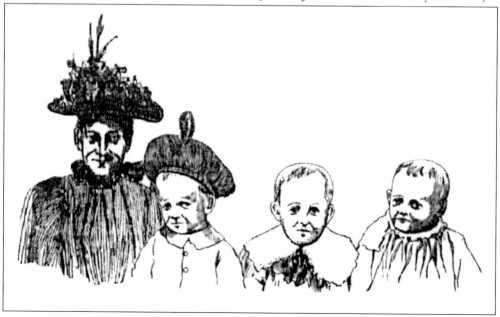

William Hummel confessed to the murders, saying that an argument between himself and his new wife accelerated out of control until he bludgeoned her and the children to death. He attempted to dispose of the bodies by loading them onto a wagon and driving to a nearby field where he tried to hide them. Back at home, he discovered the baby's body under the wagon seat so he buried it in the horse stall. Hummel was arrested, found guilty at his trial, and sentenced to hang for his crimes. The photograph at right was taken in April 1900, just a few months before he was hung at the county prison in Williamsport on June 5. Below is the invitation to the execution that was received by Hummel's nephew Ernest Moon. (Right, courtesy of the Lycoming County Historical Society and Thomas Taber Museum; below, courtesy of Joan Hoover.)

To _Ernest Moon_

You are hereby deputized to be present at the execution of

William Hummel,

within the walls of the County Jail of Lycoming County, on June 5th, between the hours of 10 A. M. and 3 P. M.

J. A. Gamble Sheriff.

SHERIFF'S OFFICE, Williamsport, Pa,,
May , 1900.

This early photograph (above) shows what was known locally as the "narrows" at the north end of Main Street heading out of town. The wooden walkway was considered a great convenience for those walking toward the Clintonville Mill (see page 49) or to visit a friend or family member who lived outside the borough limits. Below is a view of the bridge over Black Hole Creek on Old Road. At the center of the photograph is the barn near the Clintonville Mill. (Above, courtesy of the Montgomery Area Public Library; below, courtesy of the James V. Brown Library Archives.)

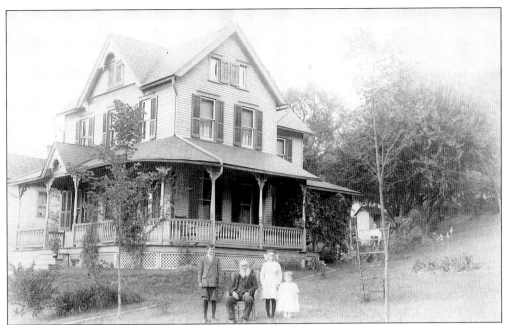

Located in the narrows is this home built by John Hain in 1906. Pictured from left to right are John's son, Wilbur, and his father-in-law, John Houck. The two girls are identified as Geraldine Tyson and Melva Hain. In the background, near the outhouse, is Mary Hain, John's wife and Wilbur's mother. In the image below, John is standing with Wilbur near their home. Water from John's spring was piped under the wooden boardwalk into a watering trough where farmers coming into town stopped to water their horses. It has been said that John kept trout in the spring to eat the bugs. (Above, courtesy of Hugh Christie; below, courtesy of Marion McCormick.)

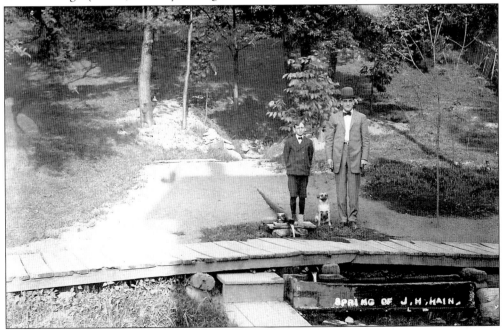

Located next to the Hain home (seen in the background; see also previous page) was the Bieber residence, pictured here in 1923. Howard Lee Bieber and his wife Margaret lived here with her parents, Phillip Monroe and Anastasia Opp Smith, and their children Wilda, Bertha, Elias Phillip, and Sara Effie. Bieber was a great-grandson of Nicholas Bieber who, along with his brothers Adam and John, served in the Revolutionary War. Each brother spelled his last name differently; namely, Nicholas Bieber, Adam Beaver, and John Beeber. To further add to the confusion, some of Nicholas's descendants switched the spelling back and forth from Bieber to Beeber. Howard Bieber operated the Clintonville Grist Mill between 1898 and 1922 and is seen below, left, with Arthur Lewis in the mill. (Courtesy of June Grube.)

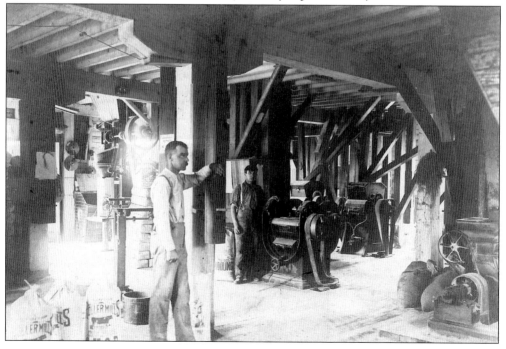

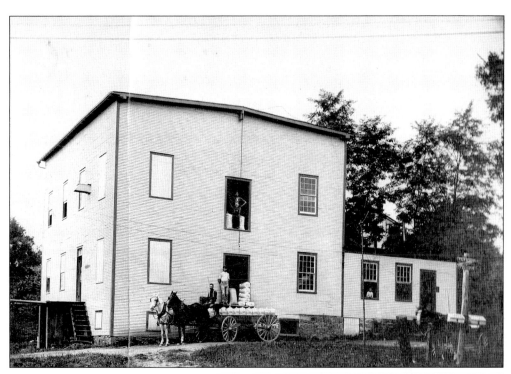

Howard Bieber learned to be a miller and, at about age 16, went to live and work with his uncle William S. Bieber, who owned a gristmill in Clarkstown, Pennsylvania. Howard went on to own and operate the Clintonville Mill in Montgomery for almost 25 years. Although he cautioned his employees of the dangerous conditions in the mill, tragedies did occur. A newspaper clipping from November 15, 1913, states: "Charles Boyer, 21, was killed this morning while at work in the grist mill of H. L. Bieber at Clintonville, a short distance from Montgomery. His clothing caught in a line shaft." Since there were no witnesses to the accident, it is unknown how Boyer became trapped on the water wheel in the basement of the mill where he was found by Bieber. (Courtesy of June Grube.)

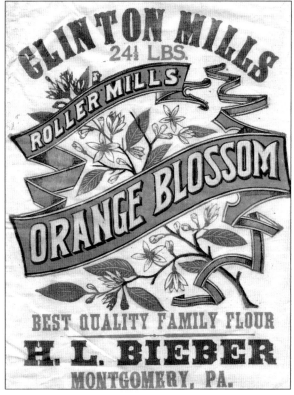

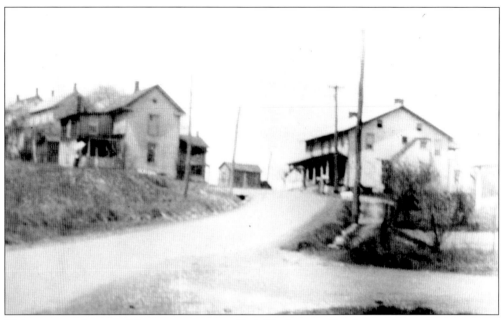

This community near Montgomery was called Pinchtown. Stories attribute the name to a penny-pinching store merchant who did business there or another possibility may have been a miserly farmer who was known as "Old Pincher" because of the low wages he reportedly paid his workers. Pinchtown Road still exists as a reminder of the frugal ancestors. (Courtesy of the Montgomery Area Public Library.)

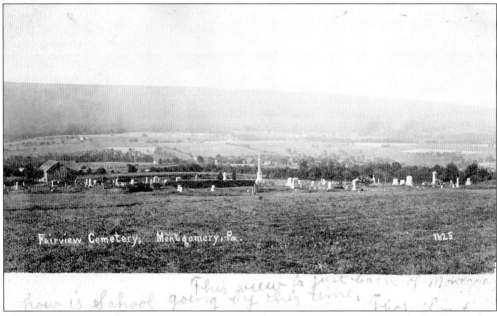

The two cemeteries closest to Montgomery are Clinton Baptist Cemetery, which is located to the east, and Fairview Cemetery, to the west, as seen above. The GAR monument (see page 40) is visible in the center of this postcard view as well as portions of the town and farmlands beyond. Also noticeable are the few number of gravestones in the foreground. (Courtesy of Pat and Donna Deitrick.)

Three

AT SCHOOL

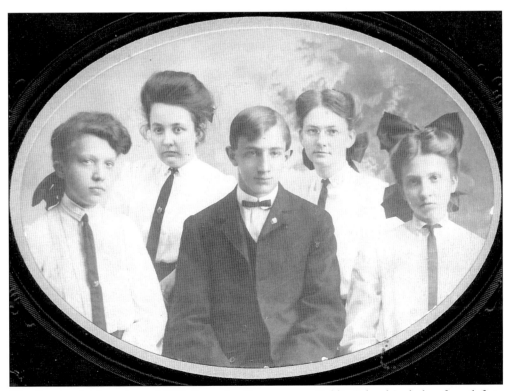

The first graduating class of 1905 from the Montgomery Public School includes, from left to right, Reba Morgat Breisch, Maria Gortner Raup, Ralph Schnee (who was elected president of the class), Hullda Piatt, and Marion Heilman Lukens. A year after their graduation, they entertained the five members of the graduating class of 1906 with a banquet at the Mansion House in Watsontown. (Courtesy of the Montgomery Area Public Library.)

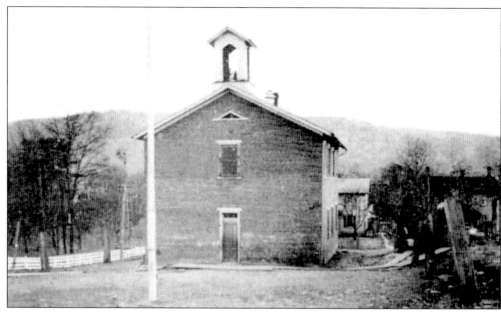

The first public school building in the borough was the Education Hall, located at the corner of Bower Street and West Houston Avenue. It served as an educational building from the 1870s until 1904, when the new public school building was erected on East Houston Avenue. Pictured below is a class photographed during the 1890 school year. From left to right are (first row) Nina Baker, Alice Miller, Jennie Housel Weller, Cora Lovelace, ? Jones, David Kuntz, Elmer Welshans, and Charles Diel; (second row) Agnes Maneval, Emma Hagenbuch Smith, C. S. Fenstamacher (teacher), Thomas Bardo, ? Shaffer, and Ollie Housell; (third row) Nettie Kendrick, Jennie Reed Bieber, Edna Kilmer Schnee, Mazie Felsburg, Jeannette Morgan Shollenberger, Mayme Burley Miller, Walter Shuler, Ed Burley, and Elmer Zellers. (Above, courtesy of the Montgomery Area Historical Society; below, courtesy of the Montgomery Area Public Library.)

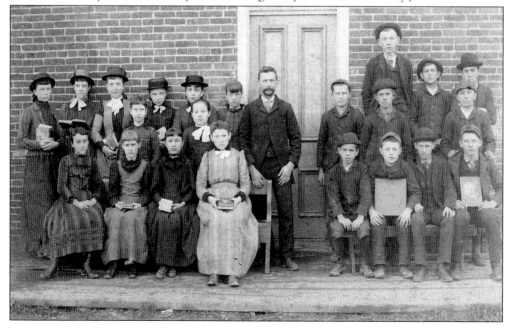

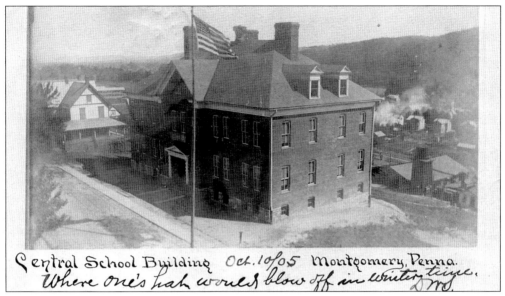

Central School Building Oct. 10/05 Montgomery, Penna. Where one's hair would blow off in winter time. LMS.

A new building (above) for all grades in the Montgomery school system was built on East Houston Avenue and was ready at the beginning of the 1904 fall term. The members of the graduating class of 1914 pictured below from left to right are (first row) Robert Pysher, Byron "Rube" Yarrison (class president and future pitcher for the Philadelphia Athletics baseball team during 1922 and 1924), Cornelius Tupper, Joseph Shelley, Ray Stewart, Weimer Hull, Freeman Moon, and Elias Gruver; (second row) Bertha Frantz Lilley, ? Shoemaker Miller, Gertrude Hall Best, Emily Piatt Shelley, Merle Bastian Swartz, Beatrice Bartlett Wolfe, unidentified, and Irene Grady; (third row) Edna Hain Stillwagon, Rae Thomas Dewalt, Alma Fowler Crommett, Leona Sherman Dewalt, Mary Doctor Schooley, unidentified, Esther Wagner Piatt, Helen Welshans Smith, and Neva Breon Tupper. (Above, courtesy of Lynn Ditty; below, courtesy of the Montgomery Area Public Library.)

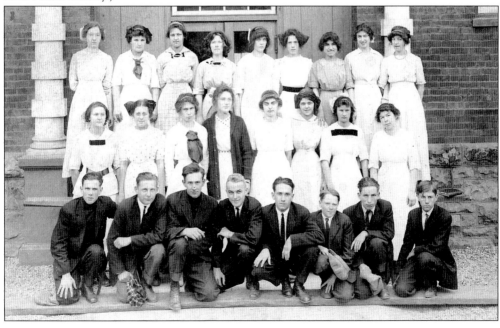

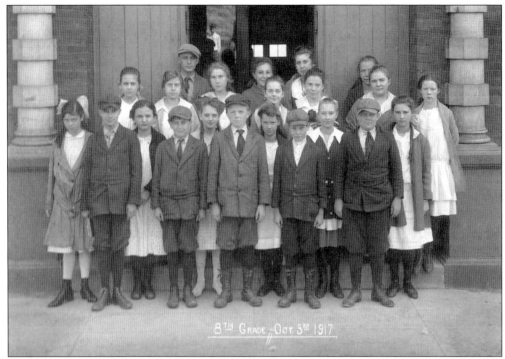

The eighth graders in 1917 are, from left to right, (first row) Frederick McWilliams, Louis Strouse, Nevin Schell, Irwin Foust, and Charles Woodling; (second row) Maggie Nuss, Katharine Zellers, Gladys Warner, Isabel Waston, Bernadine Decker, and Reba Shepard; (third row) Dorothy Shiler, Ethel Nuss, Alice Thomas, Frances Decker, Mary Menges, Martha Frey, and Ethel Hackett; (fourth row) Clyde Bowers, Rose Cooper, Stella Robbins, and Emily Staib. (Courtesy of the Montgomery Area Public Library.)

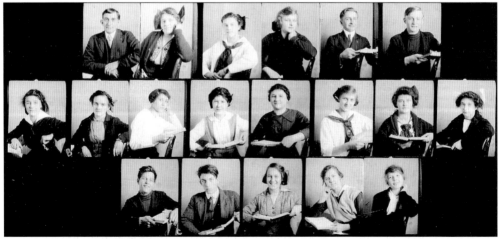

These individual candid shots include many students from the graduating class of 1918. They are, from left to right, (first row) Arthur Davis, Norman Jarrett, Dorothy Solomon, Helen Bailey, and Margaret Childs; (second row) Marguerite Phillips, Anita Zellers, Elsie Odell, Margaret Emery, Myrtle Waltman, Alverta Sealy, Beatrice Hess, and Anna Rentz; (third row) professor Lockard, Marion Fague, Cindrella Pysher, Frances Shelley, Lloyd Frey, and Oliver Watts. (Courtesy of the Montgomery Area Public Library.)

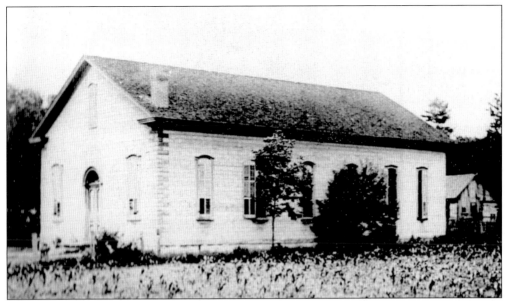

Originally the Methodist church, the Clinton Township High School (above) celebrated its first graduation ceremony on April 3, 1908, in the Montgomery Opera House. Graduates were Emma Esther Bastian, Ethel May Fowler, Anna Mae Herring, Hazel Cockroft Metzger, Georga Anna Smith, Frieda Janetta Sechler, Beulah Lisle Shaffer, Robert Lester Herring, De Lancey Metzger, Lloyd Sylvester Person, and Harvey Doyle Webb. (Courtesy of the Montgomery Area Historical Society.)

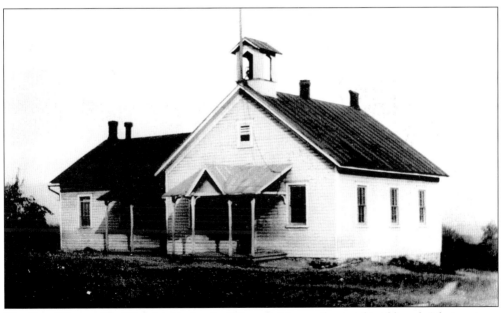

The first Clintonville School was a log building, and it was then replaced by a brick structure, which were both built on the south side of Pinchtown Road. The brick school was town down, and the new school built near Kinsey Street. An addition was built to accommodate the increase in student population and it was in use until March 7, 1927, when it was destroyed by fire. (Courtesy of the Montgomery Area Historical Society.)

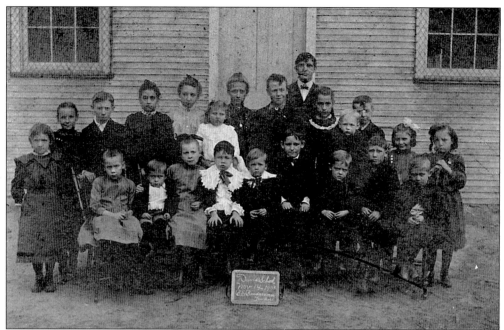

The Davis School was built about 1893 on land near the Susquehanna River that was donated by William Davis. He lived near the railroad tracks on what is now Armstrong Road. Photographed on November 14, 1903, this group of very-well-dressed students (note the large and frilly collar worn by the young boy at the center) and their teacher, B. E. Boudeman, poses for the photographer. (Courtesy of Genevieve Voneida.)

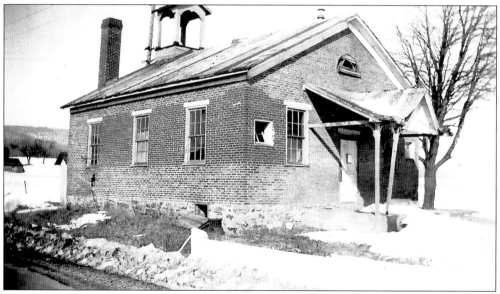

Located on Pine Street (which is now named Blind Road), the Pine Street School was moved to a neighboring farm and used as a wagon shed when it could no longer contain the number of children who attended. A new school building was erected along the Montgomery Pike near the Grange hall. That building was torn down when the highway was widened. (Courtesy of Carl Jarrett.)

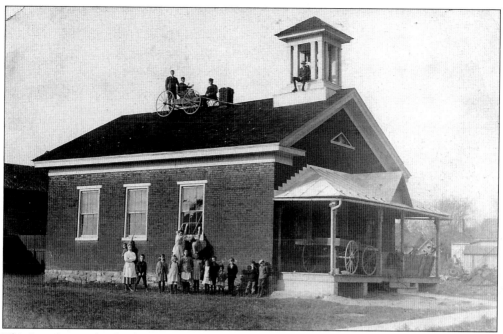

This is an image that has been reprinted in an occasional historical publication. The wagon got on the roof of the Elimsport School apparently for a Halloween prank perpetrated by some of the students. They somehow persuaded the owner of the wagon to help them disassemble it, carry the pieces up to the roof, and then reassemble it. (Courtesy of Eleanor Taylor.)

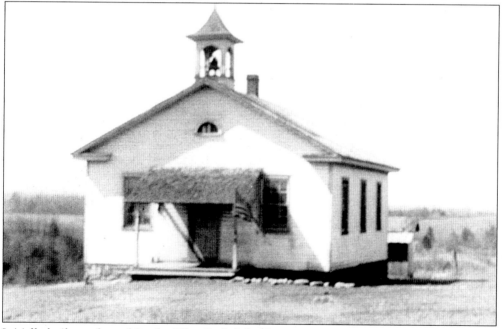

Initially built as a log cabin, the Pikes Peak School in Washington Township opened its doors in the early 1800s. Located at the top of a steep hill, it was a popular spot to go snow sledding. The teachers boarded nearby with patrons of the school. (Courtesy of the Montgomery Area Historical Society.)

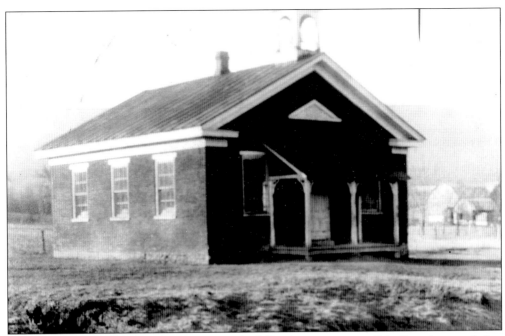

The one-room schools pictured on this and the following pages were all built as the population increased in a community and the need for a facility to educate the children increased. The White Hall one-room brick schoolhouse in Washington Township (above) is located between Elimsport and the Montgomery Pike. The Hillside School (below) was often the first school assigned to brand new teachers. This wooden structure did not, however, have a belfry on the roof which was something that was usually built on schoolhouses at that time. (Courtesy of the Montgomery Area Historical Society.)

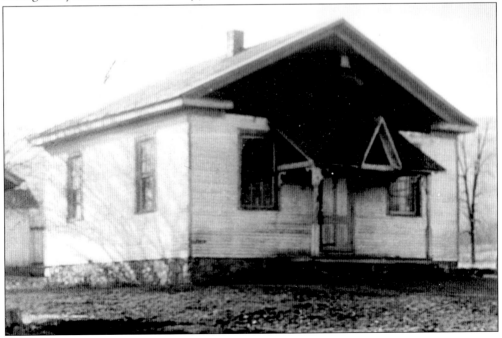

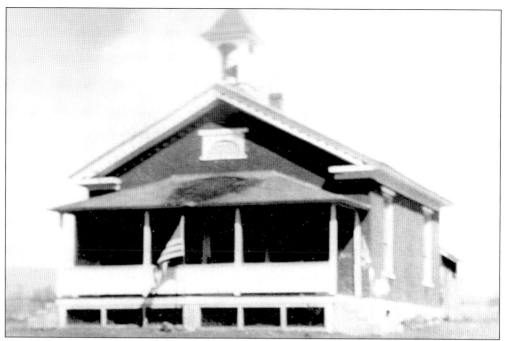

The Pleasant Green schoolhouse was another Washington Township school located near Elimsport. Although it had been closed for many years, it was reopened when the construction of the new Elimsport School was not completed in time for the beginning of the new school year. Cobwebs were swept away and for the first two months, the students were taught once again in a one-room school. (Courtesy of the Montgomery Area Historical Society.)

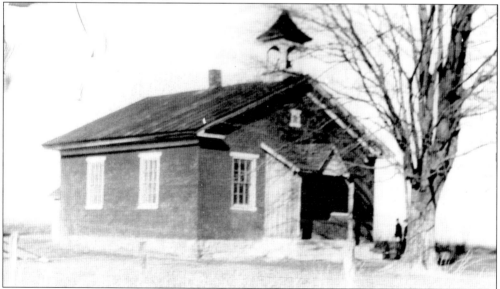

Spring Garden was a community in Gregg Township, Union County, between Elimsport and Allenwood. It was settled around 1878 when Abraham Sypher built a gristmill there. His son, Henry, took it over and the village grew slowly near the neighboring village of Alvira. The Spring Garden one-room school is pictured above. (Courtesy of the Montgomery Area Historical Society.)

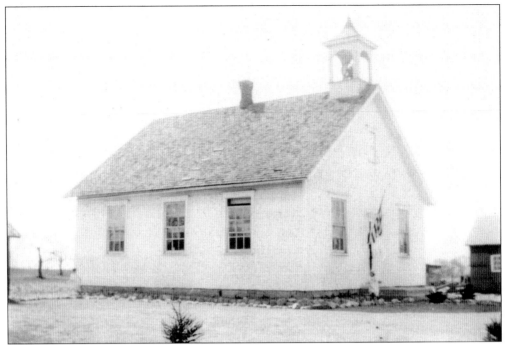

On February 20, 1896, a photographer came to the Alvira one-room school (above) to take a photograph of the class. The teacher, W. Y. Baker, wrote the name of the school, the date, and his name (in the cursive hand of a dedicated scholar) on the blackboard. He then made sure that each of his students had a schoolbook in their hands before he asked them to come to the front of the room to pose for this photograph. Their teacher did not have to admonish or scold. The children knew what kind of behavior was expected of them. (Above, courtesy of the Lycoming County Historical Society and Thomas Taber Museum; below, courtesy of Bill and Ann Miller.)

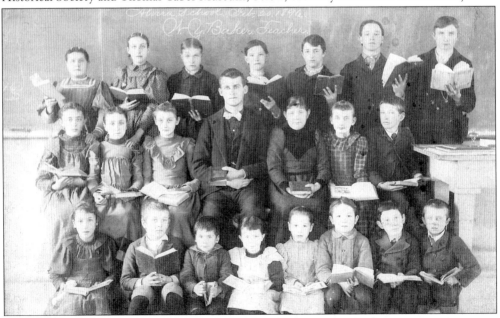

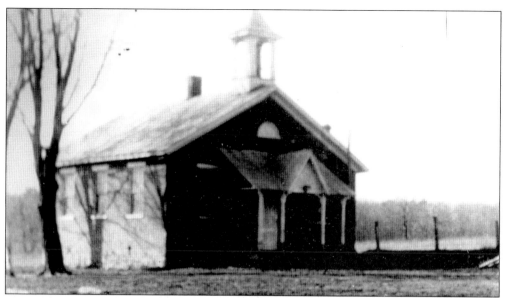

Brady Township built its first school building around 1799. It was made of round logs, oiled paper windows and a large central fireplace. Eventually it was replaced by a trio of one-room schools. The Somerset School, pictured above, was one of these three schools, located near the Montgomery Pike/Route 15. Identified in the Somerset School class photograph below are, from left to right, (first row) Luther Morehart, Cada Ellis, Carl Shrey, Harold Pysher, Ralph Beidenger, and Joseph Spong; (second row) Joe Kuhns, Elizabeth Baker, Alma Shrimp, Helen Spong, Bernice Shrey, Dorothy Boner, Madeline Reaser, unidentified, and Florence Bailey (teacher); (third row) Margret Kuhns, Rosie Spong, Dorothy Coleman, Otto Boner, Mack Lynch, Beatrice Hall, Mildred Feaster, Emma Boner, and Gladys Pysher; (fourth row) Velma Confer, Kenneth Kuhns, Fred Snyder, Merl Hall, John Snyder, Leroy Feaster, and Clifford Miller. (Courtesy of the Montgomery Area Historical Society.)

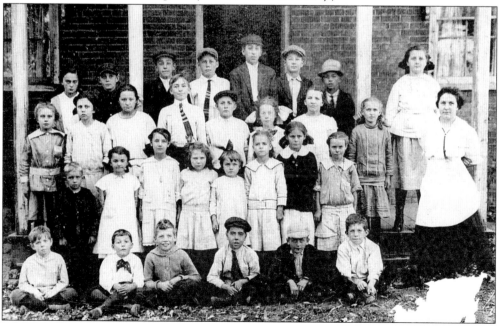

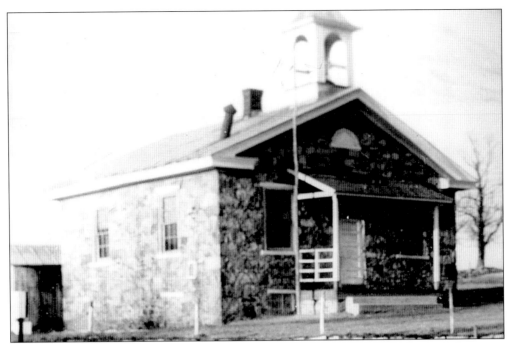

The second one-room school in Brady Township was the Stone School (above), located near the Christ Lutheran (Stone) Church (see next page). These students from the Stone School pictured below are prepared for a respite from the drudgery of spelling lessons and reading their Bible scriptures. Although only two ball bats and two mitts can be seen in the photograph, all of the children will get to enjoy their recess in the grassy fields near the school. The third Brady Township school was Oak Grove near Maple Hill, which was closed in 1958. It is now used as the township building. (Above, courtesy of the Montgomery Area Historical Society; below, courtesy of Allen DiMarco.)

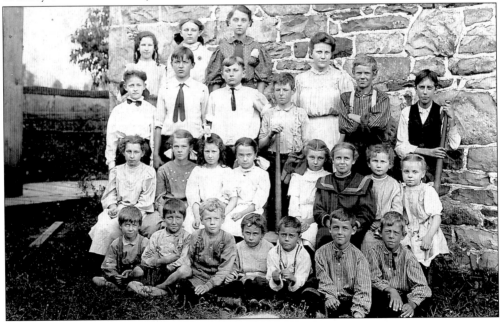

Four

AT CHURCH

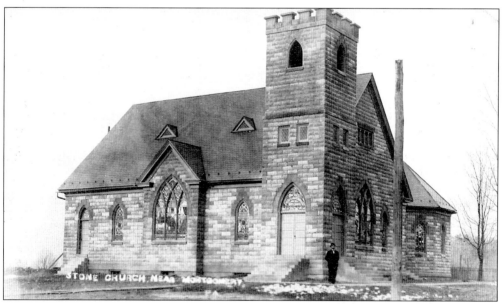

Author Conrad Richter lived with his family in White Deer Valley between 1906 and 1910 when his father, Rev. John A. Richter (seen standing in front of church above), was pastor at the Christ Lutheran (Stone) Church. The younger Richter often incorporated the scenes and characters that he came to know when he lived and worked in Montgomery. His short story, "Dr. Hanray's Second Chance," which was published in 1950, related the tale of a young man returning to his childhood home after it had been converted to a military base. The original title of the story was "The Boy He Was" and several familiar names appear throughout the narrative: Stone Church, Penny Hill, Jarretts' farm, Deckertown, and Hulsizer's blacksmith shop were just a few. (Courtesy of James Maust.)

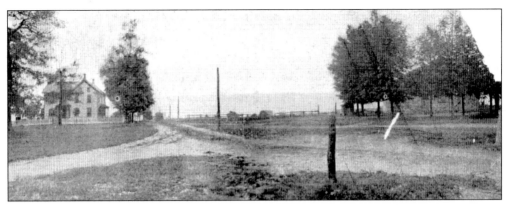

Considered the earliest organized church in the area, a group of Irish Presbyterians met sometime during the late 1780s in a log structure near the cemetery of the Christ Lutheran (Stone) Church near Alvira. These early worshipers determined that a new building should be erected and the cornerstone was laid in September 1847 on a site across the road from the cemetery. The church was the spiritual home of two congregations, the Lutherans and the Reformed. As seen in the photograph above, the parsonage was almost as large as the church itself. When Rev. John A. Richter assumed his pastorate calling for the Stone Church as well as two other Lutheran churches, the Zion Evangelical Lutheran Church (page 67) and the Messiah Lutheran Church (page 66), a new stone church building was constructed out of blocks made from the crushed stone salvaged from the old structure. (Above, courtesy of Marion McCormick; below, courtesy of Pat and Donna Deitrick.)

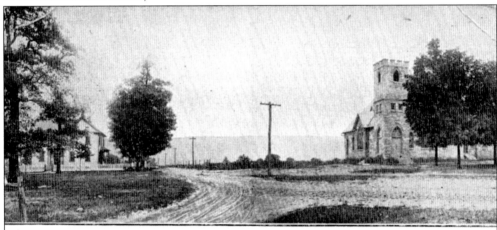

Copyright, 1908, by John H. Kelley.
Christ's Lutheran Church and Parsonage, Montgomery, Pa.

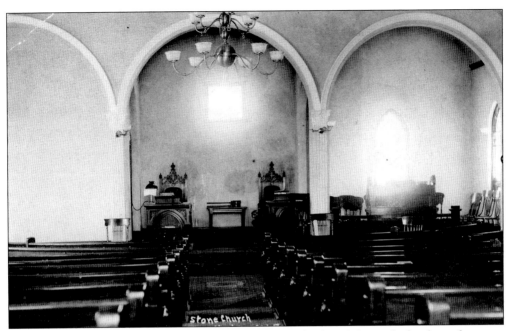

This interior views of the Christ Lutheran (Stone) Church (above) shows the hard wooden pews common to churches during the beginning of the 20th century, as well as chairs with ornately designed backs for the pastor and others. A pump organ stands at the right front. The women below were members of the Ladies Aid at the Christ Lutheran (Stone) Church. When the new church was built in 1906 and 1907, the Ladies Aid provided the first $1,000 of the $12,000 building costs. The completed church was dedicated into service on December 15, 1907. (Above, courtesy of Paul Metzger; below, courtesy of Gay and Allen DiMarco.)

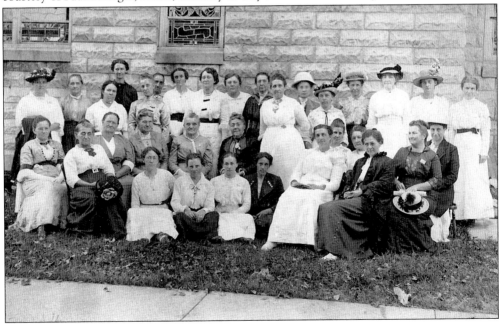

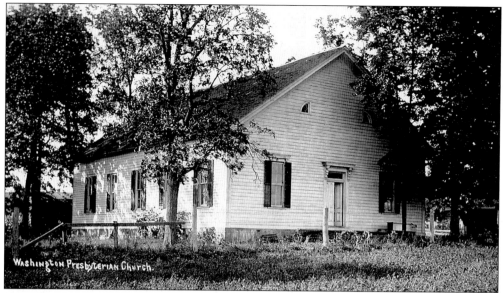

The Washington Presbyterian Church (above) was located near Alvira and organized before the 1790s. In its adjoining cemetery, the grave of a Revolutionary War soldier Elias Sechler is marked with a plaque that states: "Beneath this granite slab lies a Confederate Rifle bullet with which Elias Sechler was wounded in the charge made on Marye's Heights . . . at the Battle of Fredericksburg Virginia December Thirteenth, Eighteen Hundred and Sixty-two." Although Sechler was wounded in battle, he returned home and died in 1876 at the age of 38. The Messiah Lutheran Church (below), or the Pine Knot Church, was also located in Alvira and was dismantled along with the Washington Presbyterian Church during the 1960s. (Above, courtesy of Don and Carol Gresh; below, courtesy of the Montgomery Area Public Library.)

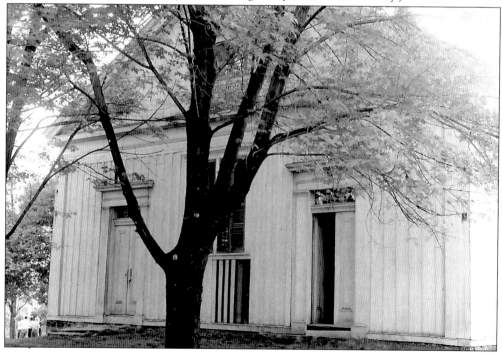

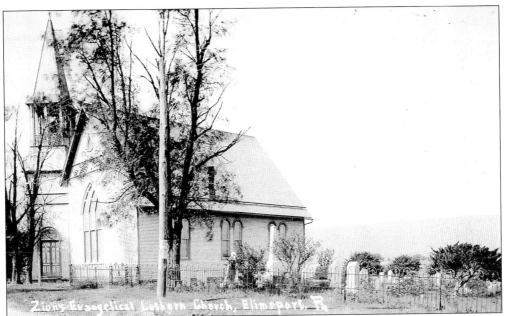

A short distance east of Elimsport is the Zion Evangelical Lutheran Church, or the "Frame Church." It was founded by the Lutheran and German Reformed societies who first met at the Stone Church. The ground for the church and the cemetery was donated by Daniel Bair. Sadly, his wife became ill, died, and was the first to be buried in the cemetery before the church was completed in 1847. (Courtesy of Eleanor Taylor.)

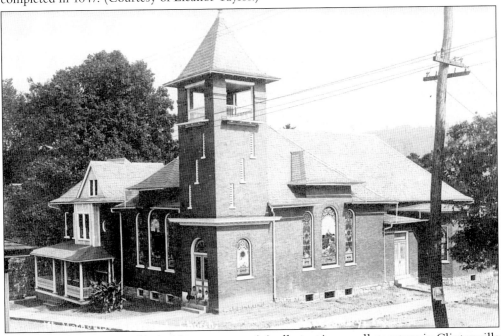

The Methodist congregation in Montgomery originally met in a small structure in Clintonville (which has since been used as a schoolhouse and a garage). Completion of this building at the corner of West Houston Avenue and Bower Street took place in November 1906 at the cost of $13,000. (Courtesy of Lynn Ditty.)

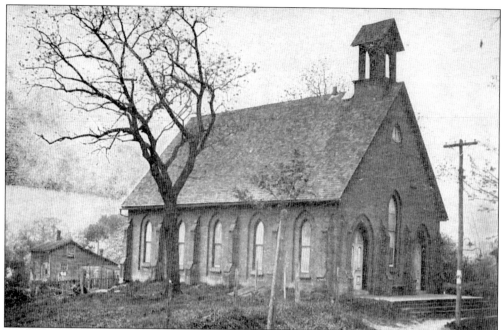

Organized in 1869, the Presbyterian church's congregation met in the town hall building on Broad Street until 1872, when this church was built on Second Street (which was known then as Ferry Road) on land donated by Phineas Barber and Ambrose Henderson, who were members of the church. It experienced growth in membership, as recorded in the church record from 1895: "during the past seven years, 70 persons have united with the church and 29 infants have been baptized." In 1931, a merger occurred between this congregation and the Grace Reformed Church, which had held services in a building on Third and Wagner Avenue. (Courtesy of Peggy Yohn.)

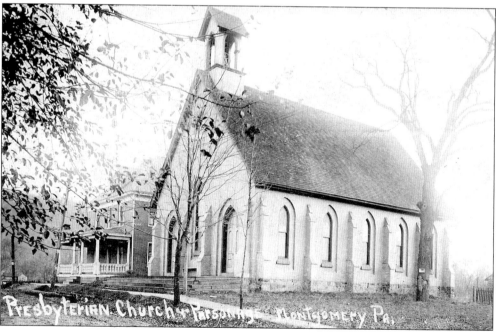

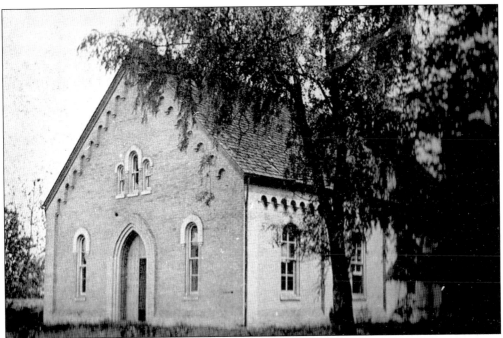

The first Clinton Baptist congregation met in 1830 in the home of Benjamin Bear, then in a nearby school, which was known as the Baptist School. In the early 1870s, a church building (above) was erected and used until 1888. In its cemetery lies the grave of Michael Sechler, who was a bodyguard for George Washington during the Revolutionary War. When the railroad tracks were laid near the church, it was decided that a church building on West Houston Avenue (below) would be safer, more convenient, and far less noisy. (Above, courtesy of the Montgomery Area Historical Society; below, photograph by E. K. Shollenberger, courtesy of the Montgomery Area Historical Society.)

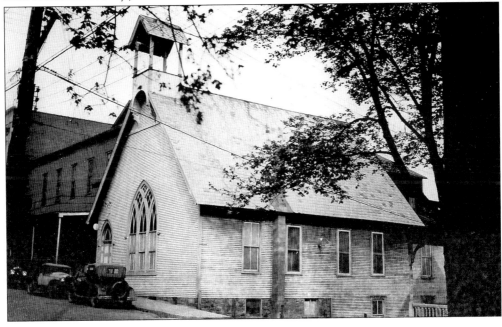

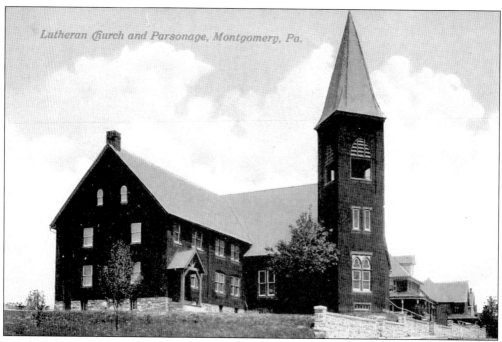

Lutheran Church and Parsonage, Montgomery, Pa.

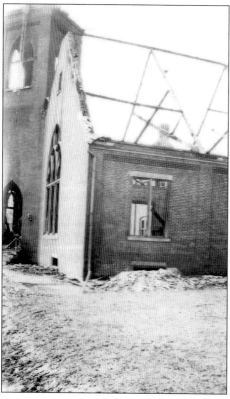

The Evangelical Lutheran church on East Houston Avenue was founded in 1888. Bricks for the new church building, which was completed in 1889, were made by a new borough industry, a brickyard operated by Israel Wagner. Four Sunday school rooms were added to this brick building during the early 1900s, and in 1927, a separate building for Sunday school was built and renovations to the worship area were also completed. Dedication services were held in December 1927, but a fire destroyed the entire church in March 1928 (left). Within a few months, in July 1928, they opened their Sunday school building, which could accommodate up to 700, for church and Sunday school services. (Above, courtesy of Sharon and Lanny Wertz; left, courtesy of Edward Miller.)

Five

AT WORK AND PLAY

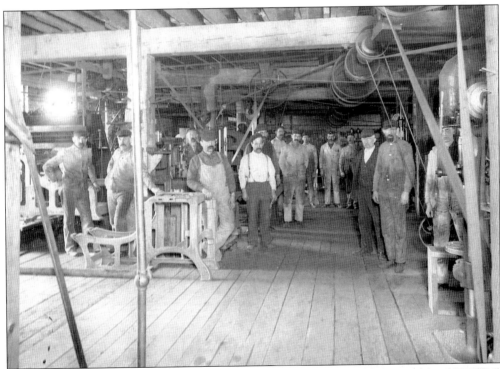

This scene of the assembly department at the American Wood Working Machine (AWWM) Company illustrates the extremely hazardous working conditions endured by the workers at the beginning of the 20th century. The men who worked in this area were not protected from the massive pulleys and belts that ran the machinery. Accidents were common, resulting in loss of fingers or hands, debilitating injuries, and even deaths occurred occasionally. (Courtesy of Marion McCormick.)

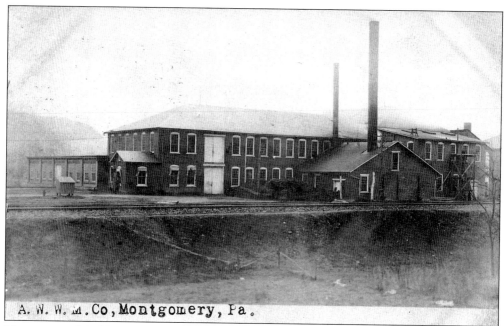

A. W. W. M. Co, Montgomery, Pa.

Montgomery Machine Company began doing business in 1870. New Hampshire businessman Levi Houston arrived in 1873 to manage the company, which eventually became the AWWM Company. In an innovative attempt to improve working conditions, Houston tried closing the factory on Saturday afternoons, paying employees for 60 hours, while they only worked 55 hours. This practice was not a popular one among Houston's peers, however, and was short-lived. (Courtesy of Galen Betzer.)

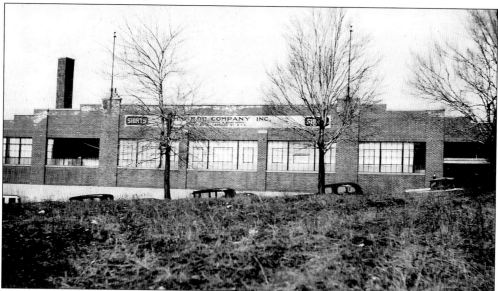

The H. D. Bob Company of New York had been operating a shirt-making business in a small building on West Houston Avenue. On July 1, 1930, it moved into a much larger building on East Houston Avenue, which was built by the Montgomery Industrial Department in an effort to encourage the business to remain in the borough. (Photograph by E. K. Shollenberger, courtesy of the Montgomery Area Historical Society.)

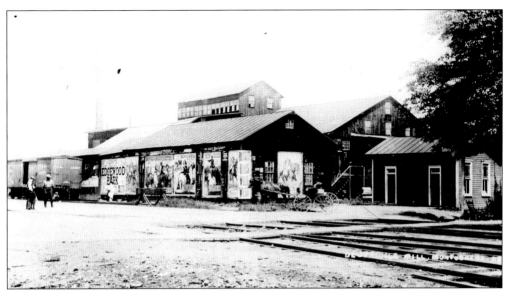

During the 1880s, another planing mill was started, H. P. Smith and Company, near the railroad tracks at Main Street. Subsequent operators included Frank E. Eck and Company and Williamsport Planing Mill Company. Thomas Deutschle and Company was the final owner, which caused it to be known as the "Dutch Mill." The plant was torn down in 1909 and the property was sold to the Reading Railroad. (Courtesy of the Montgomery Area Public Library.)

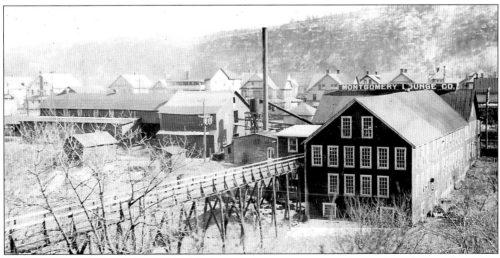

The Montgomery Lounge Company, one of several factories located on lower elevation, offered this convenience to its workers who lived on the higher end of town. The footbridge, seen in the foreground, accessed the factory from Montgomery Street. With this bridge, it eliminated the necessity to walk down a steep embankment or go the longer way around to the back of the factory. (Photograph by E. K. Shollenberger, courtesy of the Montgomery Area Historical Society.)

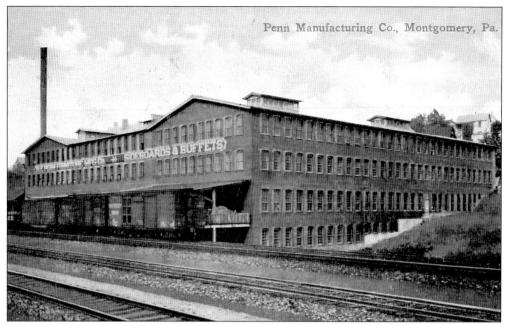

Penn Manufacturing Co., Montgomery, Pa.

In January 1903, the Sideboard Factory in Montgomery expanded and was renamed the Penn Furniture Manufacturing Company. It was another successful furniture manufacturer located in town that offered jobs to a number of residents. One of the women who chose to work was Lois Dunn, who is pictured below, left, with an unidentified coworker. She attended secretarial school around 1918 and worked a few years in the office of Penn Manufacturing before she married. Years later, Dunn's daughter remembered her mother's words of advice: "If you can work for two years for a boss, you will be a good wife for your husband." (Above, courtesy of Lynn Ditty; below, courtesy of Eleanor Taylor.)

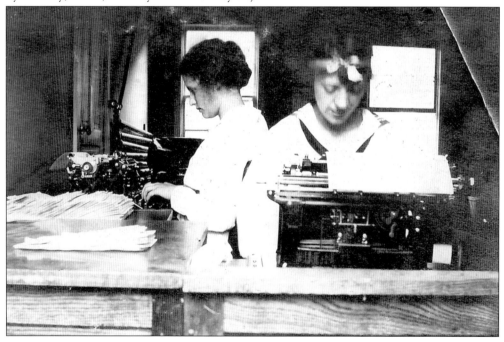

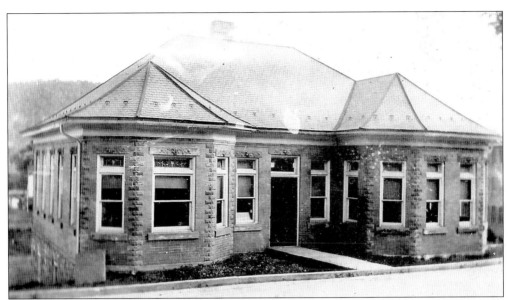

The Penn Furniture Manufacturing office building (above), in which Lois Dunn worked, was located along Montgomery Street (see also page 17). The building has since been torn down. Below is the J. D. Bair Company, which was originally Pfaff and Bair when it was begun in 1919 by J. D. Bair and Edward Pfaff. Initially a furniture repair shop on West Houston Avenue, the company built this redbrick building in the industrial section of town in 1928. (Above, courtesy of Eleanor Taylor; below, courtesy of the Montgomery Area Historical Society.)

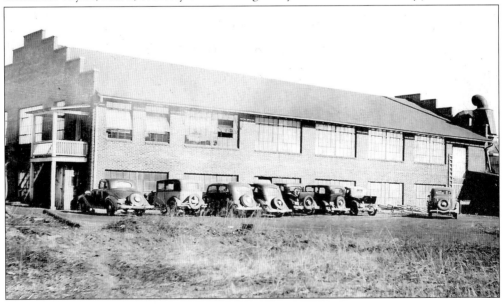

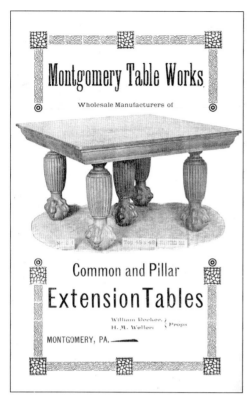

At left is an advertisement for the Montgomery Table Works company, which was started by William Decker, H. M. Weller, and C. W. Fehr in 1888. The advertisement appeared in the 1897 edition of *Grady's Directory*, a residential and business directory printed by the editor of the *Montgomery Mirror*. The Montgomery Table Works, which manufactured desks and dining and library tables, was located near Second Street, but by 1900, a larger facility was built along the railroad tracks at the end of High Street, as seen below. Less than 15 years later, another building and modern office were built and the Stokes Manufacturing Company occupied the old Table Works building. (Left, courtesy of the Montgomery Area Historical Society; below, courtesy of Hugh Christie.)

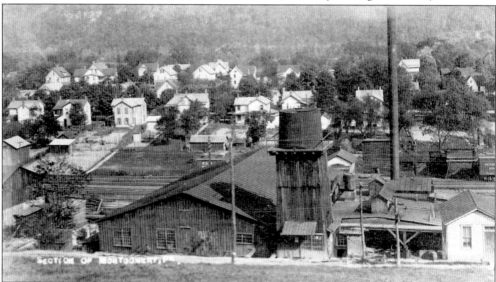

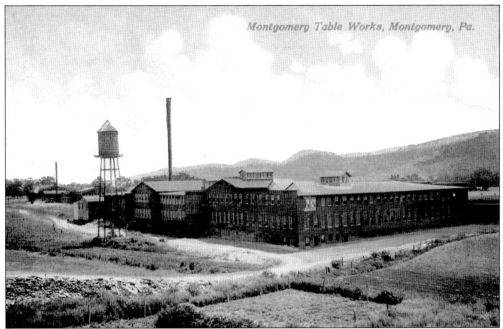

Montgomery Table Works, Montgomery, Pa.

As a result of a devastating fire that destroyed the Montgomery Table Works plant on December 3, 1892, a water sprinkler system was installed in a number of borough buildings within a few years. A number of fires destroyed churches and businesses locally, which prompted more fire prevention efforts by businessmen and factory owners. The factory complex (above) and the office building (below), which was built along Montgomery Street at the bottom of High Street, were erected in 1916. The Table Works complex was sold in 1940 to a company known as the Montgomery Mills but the following year, a fire damaged or destroyed many of the structures. The trains were delayed when bricks from the mill fell on the tracks, telegraph wires were burned, and electricity service was interrupted. (Above, courtesy of Marion McCormick; below, courtesy of the Montgomery Area Public Library.)

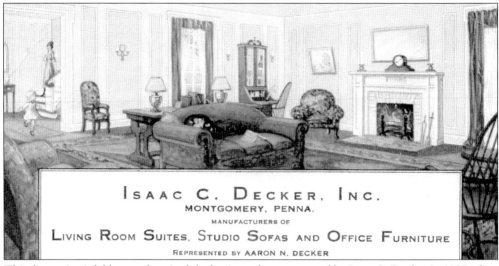

ISAAC C. DECKER, INC.
MONTGOMERY, PENNA.
MANUFACTURERS OF
LIVING ROOM SUITES, STUDIO SOFAS AND OFFICE FURNITURE
REPRESENTED BY AARON N. DECKER

This decorative ink blotter advertised the business that was started by Isaac C. Decker in 1905 when he purchased the Heilman couch factory. He enlarged the plant and manufactured upholstered living room furniture and office furniture. The Isaac C. Decker company was incorporated in 1916 with Isaac, Paul R. Decker, and Annie Decker as primary stockholders. (Courtesy of the Montgomery Area Historical Society.)

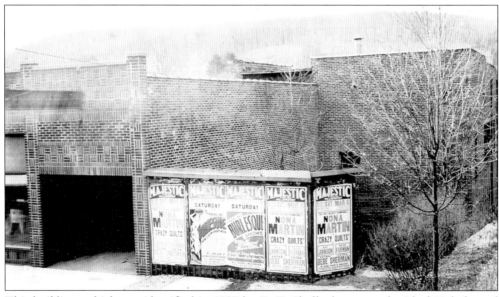

This building, which was identified in 1937 by E. K. Shollenberger as the Ideal Upholstered Furniture Company, was used as a billboard for advertising show posters for the Majestic Theater in Williamsport—namely the traveling burlesque shows and a film named *Crazy Quilts* starring Nona Martin. (Photograph by E. K. Shollenberger, courtesy of the Montgomery Area Historical Society.)

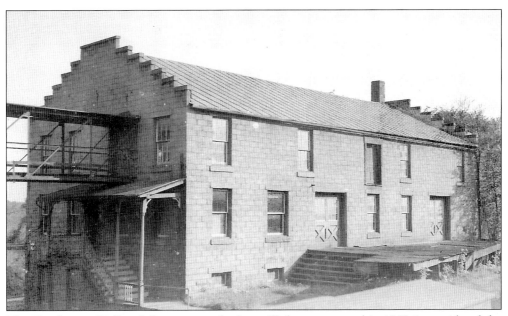

The Henderson, Hull and Company, a planing mill that was started in 1869, is considered the "parent" industry of Montgomery. Phineas Barber persuaded his cousin Ambrose Henderson, who ran a gristmill near White Deer Valley, to come to what was then known as Clinton Mills to join him in business. Henderson moved his family in 1869 into the large home near the river at the south end of Main Street. Barber and Henderson started a planing mill named P. M. Barber and Company, producing sashes, doors, shutters, and building materials. The company was consequently named Barber and Henderson, and Henderson, Hull and Company. Then in 1898, it became Montgomery Door and Sash Company until 1917, when it closed. The planing mill discontinued in 1912 and the company made furniture until 1917. (Above, courtesy of Fred Pfeiffer; below, courtesy of Marion McCormick.)

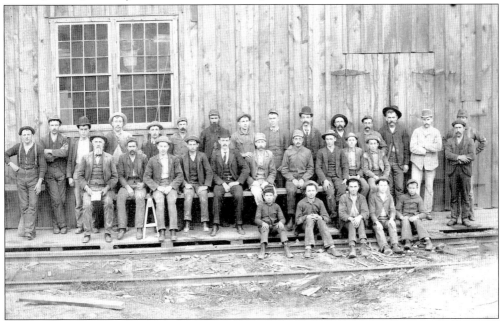

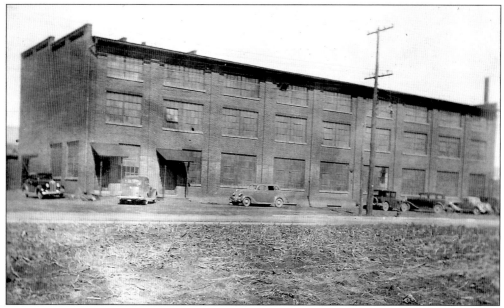

In 1910, 37-year-old Harry E. Pysher listed his occupation as "contractor" for the Door and Sash Company (see previous page). By April 1914, Pysher had gone into the lumber mill business for himself. The Pysher Furniture Desk Company was founded in 1921 and this building was constructed in 1927 to manufacture wood office furniture. (Photograph by E. K. Shollenberger, courtesy of the Montgomery Area Historical Society.)

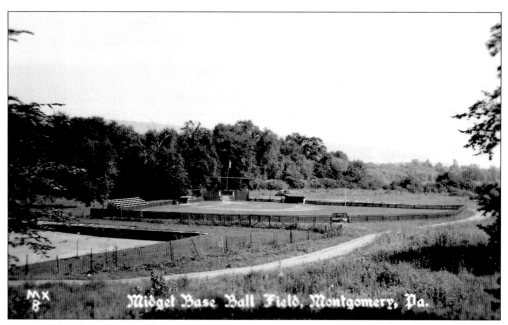

Many of the champion baseball players in Montgomery learned how to play ball on one of the area's ball fields, including this one, above. For photographs of a selection of athletic teams and a listings of team members, see pages 82 to 84. (Courtesy of Lynn Ditty.)

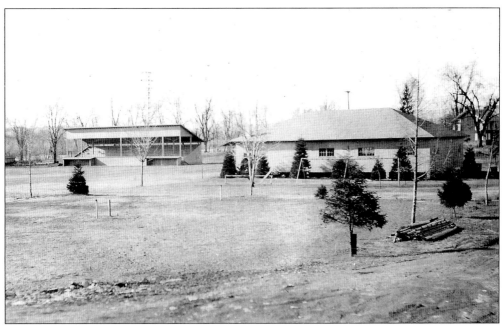

In February 1924, the process to raise money in order to purchase land for a town park was initiated. A committee consisting of Maurice Stover, Paul Decker, E. K. Shollenberger, and J. L. Miller drew up plans for the project. They raised $5,000 to purchase the land and over $10,000 to develop it. Above, the Montgomery Public Park and Playground is pictured after it was rebuilt after the flood of 1936. The new creek-fed town swimming pool (below) was constructed in 1936 by the Works Progress Administration (WPA), which was a program created in 1935 to provide jobs and income to the unemployed during the Depression. Consequently, many public buildings and roads were built, especially in rural areas. (Photographs by E. K. Shollenberger; courtesy of the Montgomery Area Historical Society.)

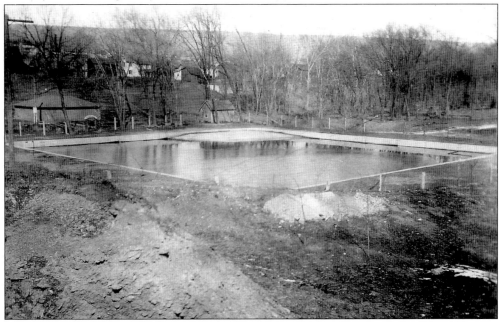

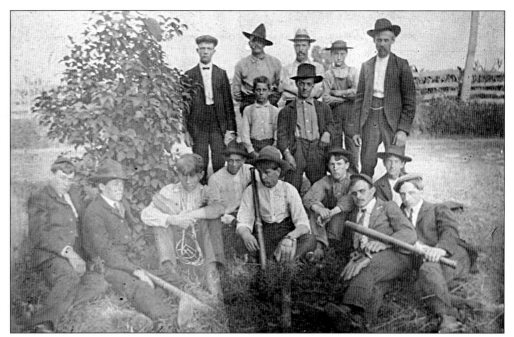

This vintage view of a baseball team, photographed around 1890, includes members from Montgomery and the immediate area. Joe Piatt is identified as the player in the back row, center, and Clyde Bower is second from the right in the first row. (Courtesy of the Montgomery Area Public Library.)

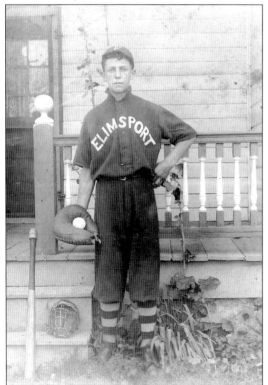

Dressed in the style of team uniforms worn at the beginning of the 20th century, this young man played for the Elimsport baseball team as a left-handed catcher. Although this postcard's image has been examined by many of the area's most historically minded individuals, this boy has not been identified. (Courtesy of Hugh Christie.)

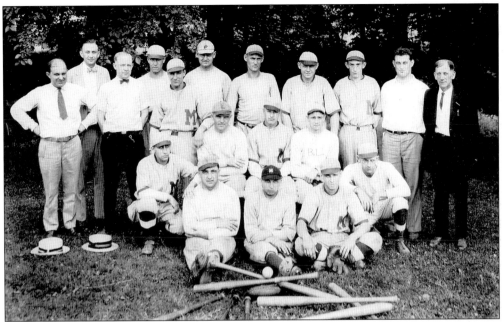

Montgomery's baseball team during the 1920s included the following, from left to right, (first row) Bill Shaffer, Van Hall, Hod Dewald, and Ben Ware (kneeling); (second row) Juggy Claudfelter (kneeling), Duke Dewald, Nicky Phillips, and Bob Tilberg; (third row) Bill Houser, Paul Decker, Bill Russell, Lil Wertman, Baldy Phillips, Van Strouse, Jake Cornelius, Les Berger, Fuzz Breidinger, Spook Ellis, and Levi Horn. (Courtesy of the Montgomery Area Historical Society.)

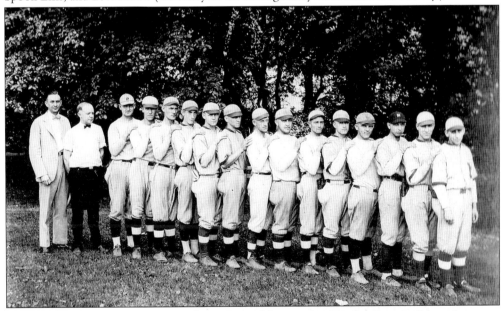

With many of the same team members pictured here as in the photograph above, they now demonstrate uniformity and teamwork. Shown, from left to right, are Paul Decker, William Russell, Van Strouse, Lil Wertman, Jake Cornelius, Fuzz Breidinger, Les Berger, Hod Dewald, Ben Ware, Bill Shaffer, Bob Tilburg, Nicky Phillips, Duke Dewald, Van Hall, Baldy Phillips, and Juggy Claudfelter. (Courtesy of Marion McCormick.)

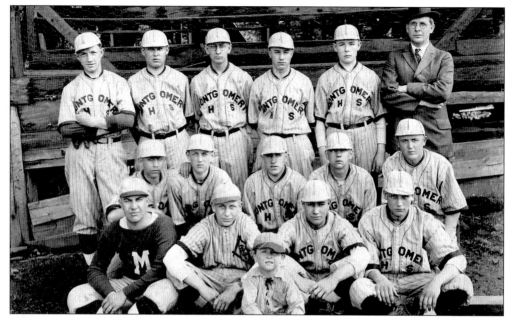

The local newspaper headlined them as "Montgomery's Crack High School Team." In this photograph the boy in front is Wayne Dewalt, and other members are, from left to right, (second row) ? Flick, Carl Stover, John Phillips, and ? Faust; (third row) Ray Anderson, ? Godfelter, Jack Wagner, Roy Kuhns, and Robert Mincemoyer; (fourth row) ? Webb, Herbert Miller, ? Strouse, Paul Phillips, ? Childs, and coach Charles W. Potter. (Courtesy of the Montgomery Area Public Library.)

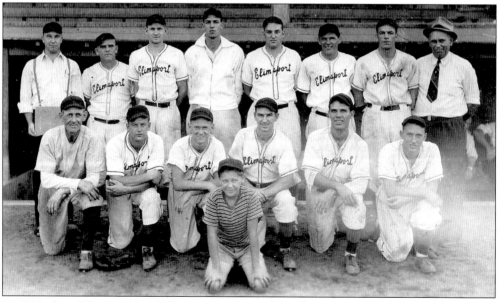

In 1939, these Elimsport baseball team members achieved success as West Branch champions. Members include, from left to right, (first row) Randy Weaver (bat boy); (second row) Mike White, Del McCormick, Bud Weaver, Cecil Best, Wally Hart, and Pat Bardo; (third row) ? Vandine (scorekeeper), Duke Dewald, Kermit Vandine, Jack Byers, Skeet Nesbitt, Barney Weaver, and Ollie Byers with team manager William McCormick. (Courtesy of Keith McCormick.)

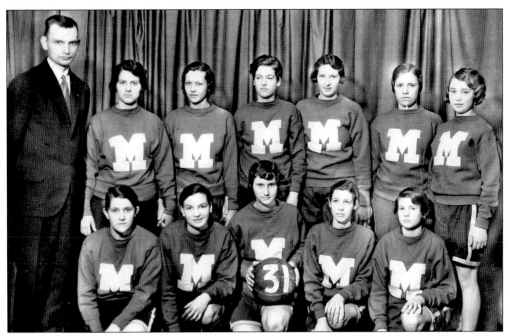

The 1931 girls high school basketball team members pictured above from left to right are (first row) Louise Zellers, Stella Felix, Viola King, Ellen Louis Armstrong, and Miriam Shook; (second row) coach Harer, Adeline Pfeiffer, Pauline King, Mary Parsons, Lois Gordner, Mabel Newhard, and Geraldine Phillips. Below, Michael Guido was the coach for this championship football team, which includes, from left to right, (first row) Richard Breon, George Stewart, Robert LaForme, Fred Pfeiffer, Charles Newhard, Ernest Brandt, Keays Carpenter, Joseph Lukens, and Lewis Bingaman; (second row) Jack Wagner, Emery Jarrett, Robert Stamets, Franklin Reaser, Forde Reeser, ? Haines, Kenneth Odell, ? Nuss, and Delbert Walborn (captain); (third row) ? Myers, Harold O'Conner, Charles Shiflet, Harold Emery, Mahlon Thomas, William Pfeiffer, ? King, Harlan Thomas, Ned Shuler, ? Hughes, and coach Michael Guido. (Courtesy of the Montgomery Area Public Library.)

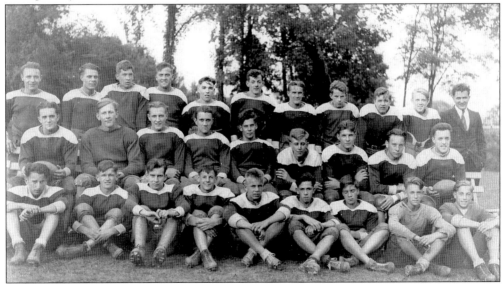

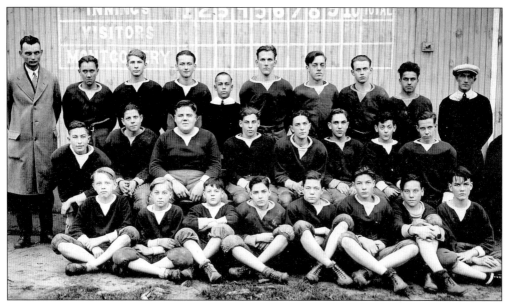

The 1929 Montgomery football team members pictured here (above) are identified as, from left to right, (first row) Van Hughes, Lewis Bingaman, Fred Pfeiffer, Don Grady, Harold Fowler, Kenneth Odell, Harold Nuss, and John Welsh; (second row) Robert Persun, Harold Herman, William Bensinger, Fred Reaser, Jack Wagner, Philip Hartranft, William Pfeiffer, and Robert Armstrong; (third row) Howard Harer, Frank Reaser, Ernest King, Elwood Miller, Max Williamson, Robert Burmeister, Delbert Walborn, Joe Koontz, Albert Opp, and coach Tim Brandt. Another photograph (below) of the same football team shows select members who will become champions within a few years. They are, from left to right, (first row) Jack Wagner, Philip Hartranft, William Bensinger, Elwood Miller, Harold Herman, Leroy Kuhns, and Albert Opp; (second row) Robert Persun, Donald Grady, Delbert Walborn, Robert Burmeister, and coach Tim Brandt. (Courtesy of the Montgomery Area Public Library.)

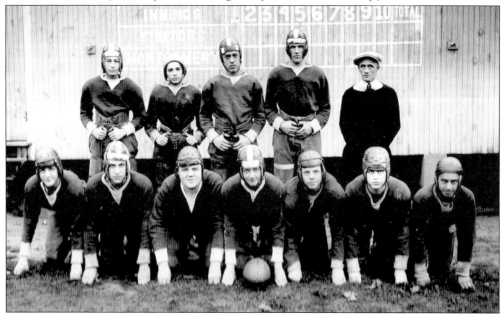

Six

DOWN AT THE RIVER

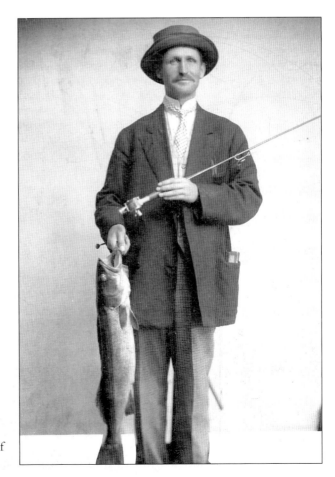

William Decker was a wealthy, respected member of the community. In 1905, he owned the Montgomery Table Works and was president of three organizations: the Montgomery Electric Light and Power Company, the Montgomery Furniture Company, and the H. Hughes Store Company. He was vice president of the Penn Furniture Manufacturing Company and vice president of the First National Bank of Montgomery. But in his spare time, he enjoyed fishing in the local Susquehanna River. (Courtesy of Marion McCormick.)

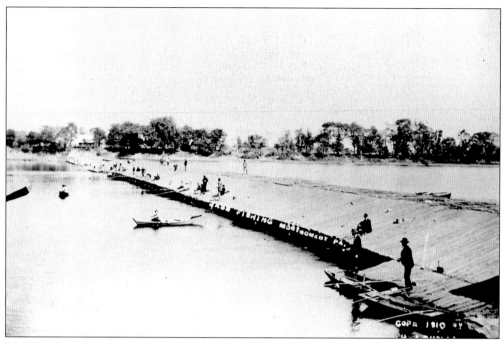

This dam located to the east of the borough was built in 1828 as a part of the canal systems, but by 1913, it was destroyed due to the high cost of maintaining it. Before that year, however, it was a popular spot to fish for bass, as this postcard image shows. (Courtesy of Marion McCormick.)

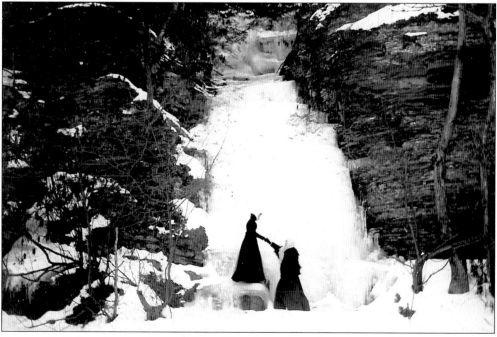

Buttermilk Falls was a popular spot for a hike all year round. A former girl scout remembers hiking to the falls with an egg in one pocket and an orange in the other. For breakfast, the orange was cut in half, the fruit scooped out, the egg cracked into the orange skin half, and cooked over a fire. (Courtesy of Edward Miller.)

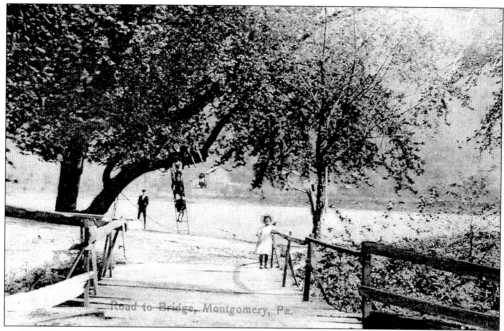

Before the bridge across the Susquehanna was built at Montgomery, the only way to cross the river was by boarding this reliable ferry boat. If one arrived at the edge of the river and the ferry happened to be on the other side, it could be summoned by ringing a bell. At night, a ferry attendant slept in a shed along the shore to serve those who wanted to cross. (Above, courtesy of the Montgomery Area Public Library; below, courtesy of Marion McCormick.)

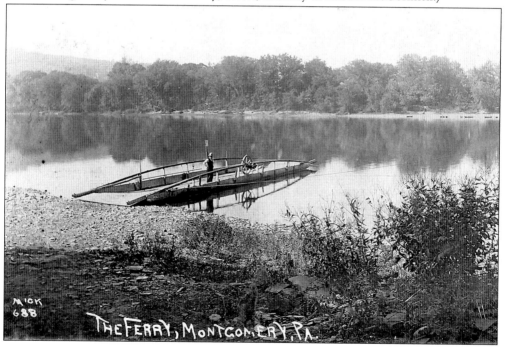

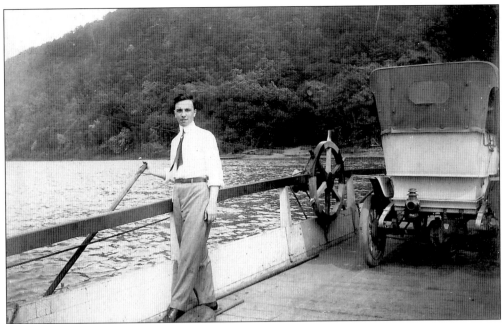

Posing for a photograph—instead of taking one—is Edmund Kennard (E. K.) Shollenberger around 1911, as he is traveling across the river on the Montgomery ferry. Shollenberger photographed, and therefore preserved, many scenes in and around Montgomery during the 1920s and 1930s. Many photographs in Montgomery family photograph albums are stamped "E. K. Shollenberger" on the back. (Courtesy of the Montgomery Area Historical Society.)

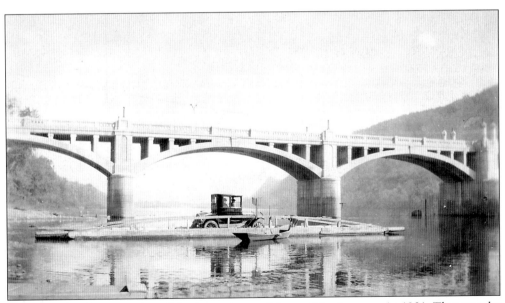

This is the last ferry crossing of the Susquehanna River at Montgomery in 1921. That was the year in which the new "free" bridge was completed and opened for traffic. (Courtesy of the Montgomery Area Public Library.)

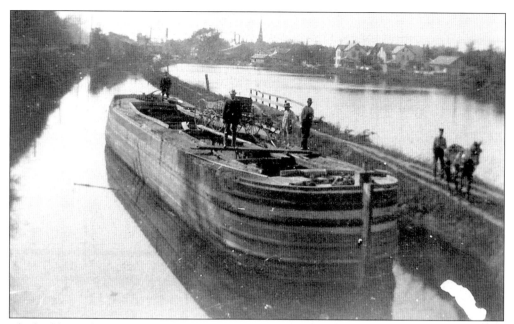

The building of the West Branch Division of the Pennsylvania canal system was begun in 1828 and completed in 1835. The canals were used extensively to transport lumber, merchandise, and passengers, but in December 1854, the first train went through Black Hole Valley. By the end of the Civil War, canal use declined dramatically. Pictured here is one of the last canal boats to float on the Susquehanna River at Montgomery. (Courtesy of Marion McCormick.)

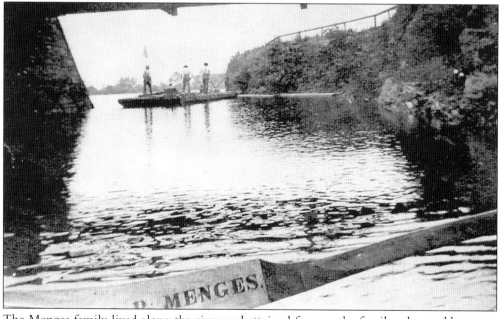

The Menges family lived along the river and attained fame as the family who could prepare delectable eel dinners. In the February 18, 1898, edition of the *Montgomery Mirror*, one of their meals was described: "The eels were served up in the usual delicious manner . . . and the bones that were left made a double track railroad from one end of the long table to the other." (Courtesy of Marion McCormick.)

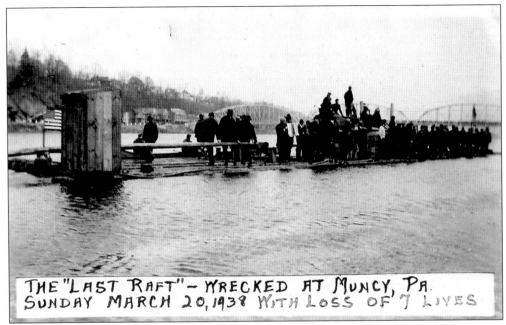

THE "LAST RAFT" – WRECKED AT MUNCY, PA.
SUNDAY MARCH 20, 1938 WITH LOSS OF 7 LIVES

To commemorate the area's legacy in the lumbering industry, a "last raft" was floated down the Susquehanna River in March 1938. Among the passengers on the square-timber raft was Montgomery's burgess and resident dentist, Dr. Charles Francis Taylor. Tragically, the raft hit one of the piers of the Reading Railroad bridge near Muncy, upstream from Montgomery, and Taylor was one of seven who perished. (Courtesy of Hugh Christie.)

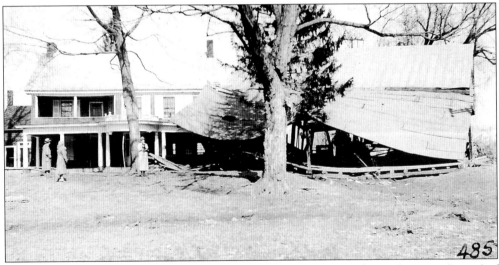

During the flood in 1936, a three-story barn near the historic Henderson home at the end of Main Street was washed off its foundation and floated into the side of the house (above). One of the Henderson family descendents remembers the story of another flood in 1889 when the piano that was in the first floor parlor was flipped upside down. (Photograph by E. K. Shollenberger, courtesy of the Montgomery Area Historical Society.)

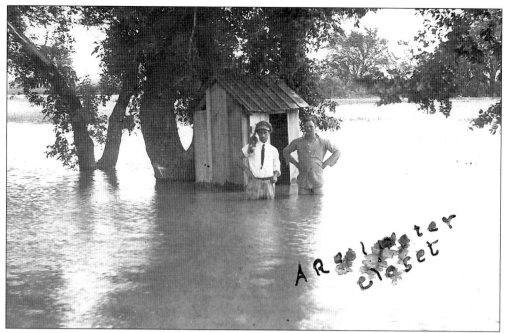

Flooding in Montgomery was common, as this postcard of "A Real Water Closet" shows. A major flood hit the area in 1889 but every spring brought threats of high water. In the March 25, 1898, edition of the *Montgomery Mirror*, the headline read, "Good Size Flood—The West Branch went on one of its excursions this week, and gave a number of the low land citizens a thorough scare." (Courtesy of Hugh Christie.)

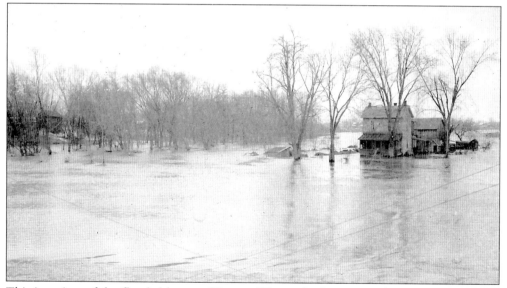

This is a view of the flooded home of Barney Wertz, the ferryman who tended to travelers when they needed to cross the Susquehanna River at Montgomery. Up until 1919, when the bridge over the river was built, the ferry or row boat manned by Wertz was the only way to get from one side of the river to the other. (Photograph by E. K. Shollenberger, courtesy of the Montgomery Area Historical Society.)

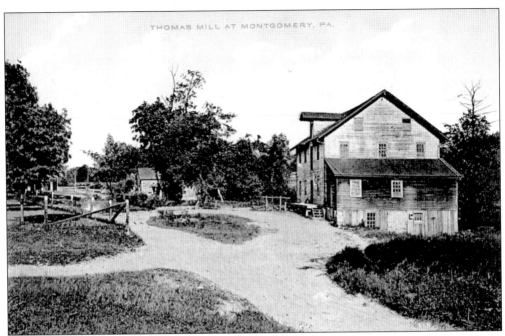

Above is a view of Thomas Mill. Below is a *c.* 1910 view of the Thomas Dam with two of the borough's young residents, 30-year-old Levi Horn, standing near the tracks and 16-year-old David Love Jr. standing at the telegraph pole. Perhaps they are discussing their next fishing excursion or maybe they are retelling the old tale of counterfeiters who hid in nearby Graham's Hollow near the old canal. Trapped by federal agents, these distributors of bogus bills reportedly found a way to escape capture in the caves of Muncy Hills. (Above, courtesy of the Montgomery Area Public Library; below, courtesy of Lynn Ditty.)

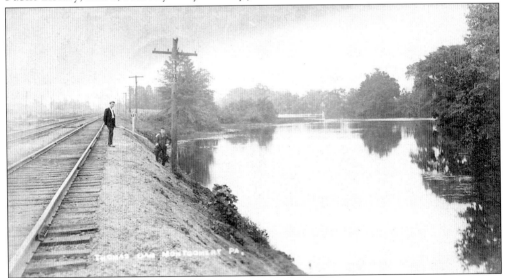

Seven

ALONG THE TRACKS

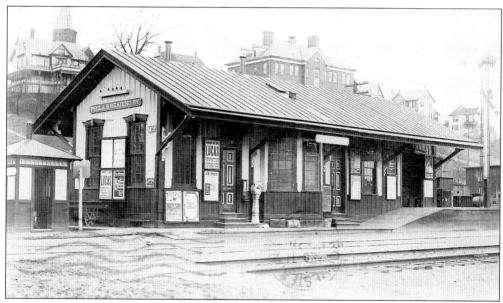

Montgomery boasted two train stations and two sets of railroad tracks. The Pennsylvania Railroad station was located just west of this station for the Philadelphia and Reading Railroad. These two rails serviced the large industrial area in the southern part of town along the Susquehanna River. The large school building is easily seen behind the station at the top of the hill on Houston Avenue. (Courtesy of the Montgomery Area Historical Society.)

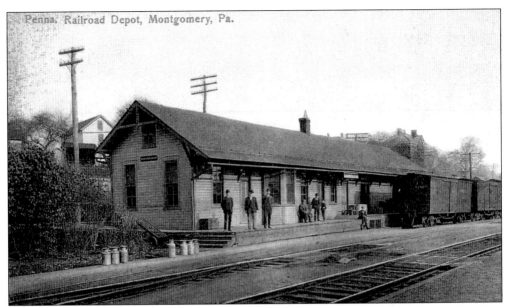

After Pres. William McKinley was assassinated in September 1901 while attending the Pan–American Exposition in Buffalo, New York, his body was transported by train to Washington, D.C. All business was suspended in Montgomery for the hour when the funeral train passed through town. The residents stood silently with flags and banners and saved the souvenir coins placed on the tracks to be pressed by the locomotive wheels. (Courtesy of Lanny and Sharon Wertz.)

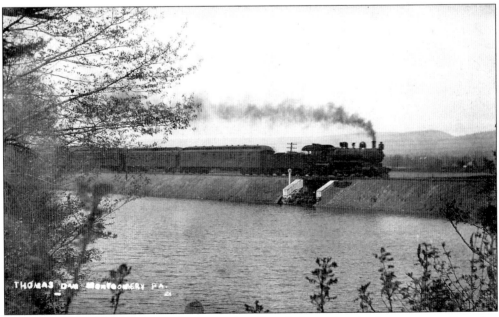

On June 7, 1939, the residents of Montgomery found themselves in the presence of royalty. England's King George VI and Queen Elizabeth visited Niagara Falls and then traveled through New York and Pennsylvania on their way to Washington, D.C. At 5:40 a.m., the royal train rumbled through Montgomery, a fact that was not made public until later that day. (Courtesy of Lynn Ditty.)

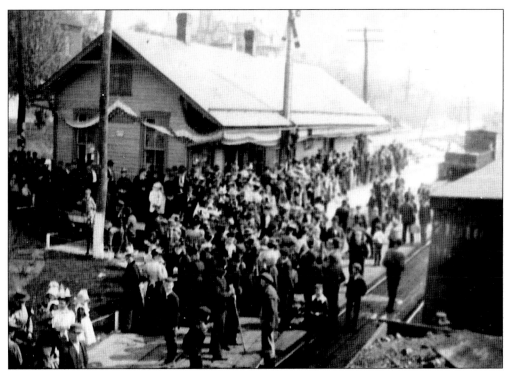

Montgomery welcomed back their young soldiers who fought during World War I with garlands and flags and celebrations and marching parades. Above is the scene at the railroad station as the townspeople wait for the return of their boys from war. Not all retuned, however; six Montgomery-area men perished in battle. Below is a view of the Pennsylvania Railroad Bridge crossing the Susquehanna River. (Above, courtesy of the Montgomery Area Public Library; below, courtesy of Lynn Ditty.)

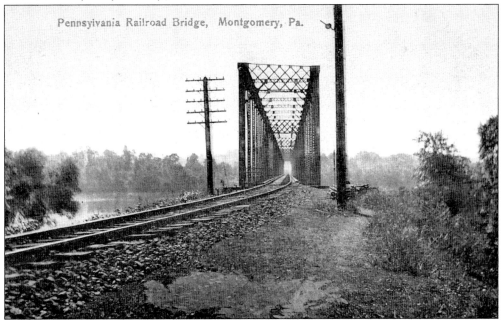

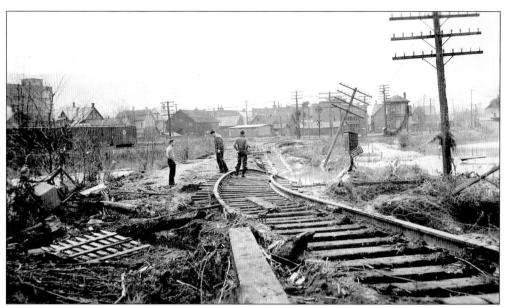

The frequent flooding wreaked havoc on the railroad tracks in Montgomery. Two weeks before the flood of May 1889, the *Montgomery Mirror* printed its premier issue. When it printed its *Extra* to report on the flood damage, the headline was "Landslides, Washouts and No Trains." Above is a visual of the damage to the tracks during the flooding of 1936. (Courtesy of Edward Miller.)

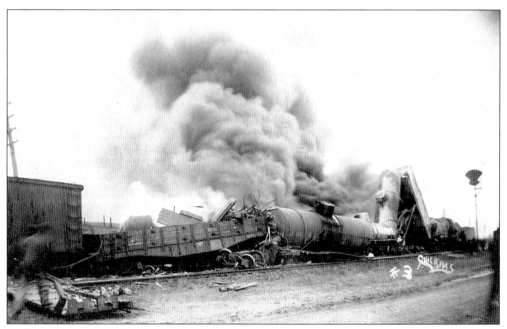

This twisted wreckage from a train derailment in nearby Dewart attracted onlookers and photographers. Train wrecks could cause catastrophic damage and often death. In 1932, the St. John Lutheran (Brick) Church suffered a devastating loss when their young pastor, Rev. William R. Schwirian, his wife, and three relatives were killed while riding in a car that was struck by the Reading passenger train at the crossing near the church. (Courtesy of Eleanor Taylor.)

Eight

LIFE IN THE COUNTRY

Commenting on the hard-working farmers of the valley in his 1910 publication, *White Deer Yearbook*, Rev. John A. Richter wrote, "Farming has played the most important part in the history of the valley . . . there is scarcely a tiller of the soil between the two mountains who cannot handle a canthook [a logging tool], skid a log, or discern a promising tract of trees with the same ease that he forks his hay, hauls his fodder, or picks out the best field on the farm." Some of these farmers are seen here with a threshing machine that was powered by the locomotive-like steam engine. Abram Sealy, the man with his right arm raised and his hand on the rear wheel of the engine, is the only identified person in this real-photo postcard image, but the others are most certainly either members of his family or neighbors. Sealy lived near Spring Garden with his wife, Grace, and their children Elverta, Ida, Mary, John, Bernice, and Georgey. (Courtesy of Allen and Gay DiMarco.)

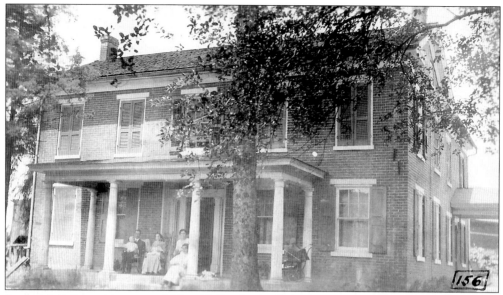

Frederick Follmer Metzger and his wife Bertha Hoffman Metzger lived in this home (above), which is located near the St. John Lutheran (Brick) Church Cemetery. Frederick is pictured below with his family who are, from left to right, (first row) Sarah Margaret Moyer (sister), Sarah Ann Follmer Metzger (mother), Frederick Metzger (father), Abigail Myers Buss (sister), and Dr. William Edmund Metzger (brother); (second row) Martha Jane David (sister), Ephriam Clark Metzger (brother), George Phillips (cousin), Frederick Follmer Metzger, Susan Lavina Hartranft (sister), Harriet Clementine Metzger (sister), and Wilmina Bussom (sister). Dr. William E. Metzger took care of the medical needs of those living in the Elimsport and Alvira area. (Above, photograph by E. K. Shollenberger, courtesy of the Montgomery Area Historical Society; below, courtesy of Paul Metzger.)

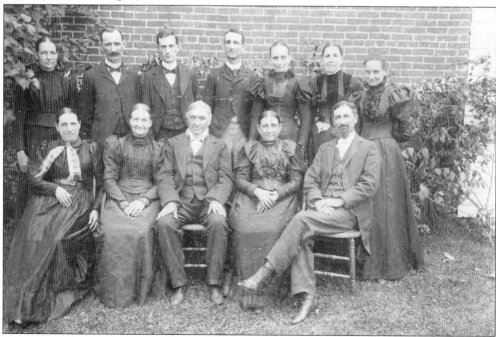

Pictured above is the McCauley House at the State Industrial Home for Women, which opened in 1920. Located near this facility was a farm owned by Paul Stein during the early 1900s. In the basement of the Stein farmhouse was a secret tunnel that ran under the fields and emptied out at the Susquehanna River. This was one of the Underground Railroad stops for runaway slaves. (Courtesy of the James V. Brown Library Archives.)

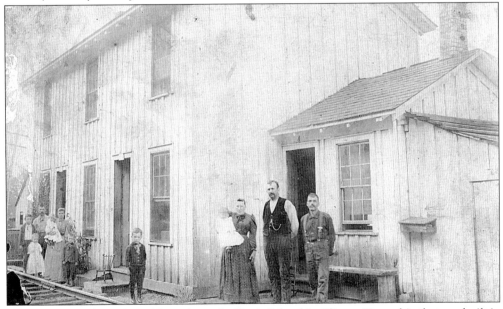

At the train station at Guise Town (near the Davis School in Clinton Township that was built in 1893), Layton and Lillie Bryington are pictured at the left with their children, from left to right, Harry, Anna, Grace (in her mother's arms), Charles, and William (standing alone, center). In the center of the photograph are James Knouse and his wife, holding their son, Harry. At right is John Frederick Davis. (Courtesy of Genevieve Voneida.)

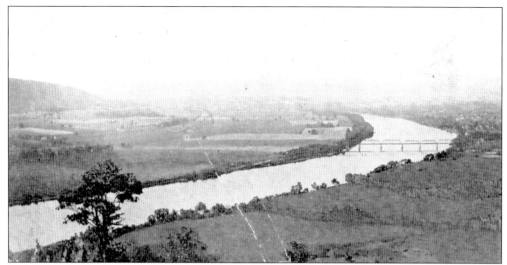

The origin of the name Black Hole Valley can never be determined for certain. The story has been told that when early pioneers saw the forest valley of dense growth, it looked like a great black hole. Others attribute the name to a long-ago fire that burned the valley, and yet others tell the tale of settlers mired in a swamp of black and sticky muck. (Courtesy of Hugh Christie.)

The Bennett and Diehl families lived along Snaureytown Road, and pictured here around 1904 are, from left to right, (first row) Harold Diehl, Susan Bennett Swisher, Helen Diehl, Bink Bennett, and Hearvy Bennett; (second row) Frank Bennett, Raymond Wertz, and Florence Bennett Kinney; (third row) Sylvester "Buzz" Bennett, Mary Hill, Gladys Diehl holding Rose Diehl, Bertha Diehl, Sarah "Sadie" Wertz Bennett, and Jack Wertz. (Courtesy of Janet Bennett.)

Robert Porter emigrated from Ireland and settled on farmland near the Montgomery Pike at the intersection of Blind Road. He established a gristmill, which was named Porter's Mill, and lived out his life with his daughter, Hannah, and her husband, Luke Egar, who was instrumental in establishing the state's first Grange (see below). (Courtesy of Sharon and Lanny Wertz.)

This display was presented by the Clinton Township/Eagle Grange No. 1 at the Hughesville Fair in 1934. This Grange was the first one formed in Pennsylvania, at the request of Robert Porter's son-in-law, Luke Egar. Eagle No. 1 celebrated its 100th year in 1971. The original Grange building that stands along Montgomery Pike was built on land purchased in 1887, possibly from the Egar/Porter estate. (Courtesy of the James V. Brown Library Archives.)

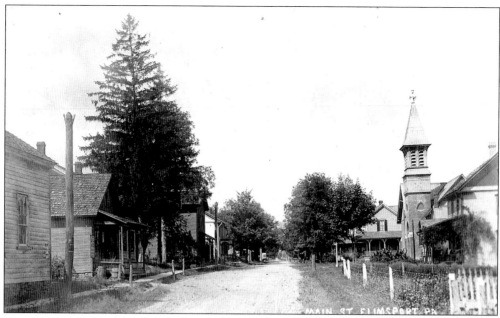

The village of Elimsport in Washington Township got its name from a German Methodist minister who settled there and wanted to call it Elam, citing a biblical reference. But there was another Elam in Delaware County, Pennsylvania, so it was decided to call the place Elimsport. The village was once an important lumber center with a large tannery and surrounded by farms. (Courtesy of Eleanor Taylor.)

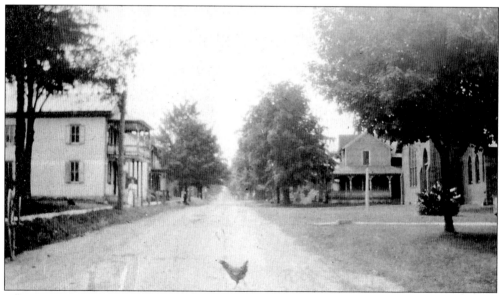

Many of the incorporated boroughs in the early 1900s adopted ordinances that did not allow animals to be kept within town limits. These rules did not sit well with the rural home owners who were accustomed to raising pigs and chickens in order to feed their families. Obviously there were no rules like this in Elimsport—chickens on the road were a common sight. (Courtesy of Eleanor Taylor.)

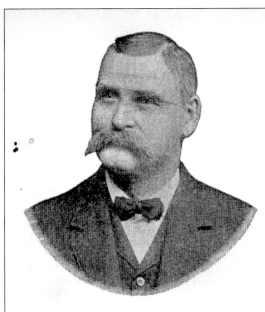

Charles VanHouten

PRACTICAL AUCTIONEER

Have been in the Auctioneer Business
for 30 Years.

BEST OF REFERENCE

For Information Address or Telephone
ELIMSPORT HOTEL EXCHANGE HOTEL
Elimsport. Pa. Market St .
Williamsport, Pa.

During the late 1800s and early 1900s, outdoor auctions were the primary means to sell household items, farm equipment, and often entire farms. An auctioneer would be hired, a lunch prepared, and the sale would begin early in the morning. Items such as rocking chairs, coverlets, featherbeds, and even cows, hay, shingles, wagons, and hand rakes would be available for sale. (Courtesy of Pat and Donna Deitrick.)

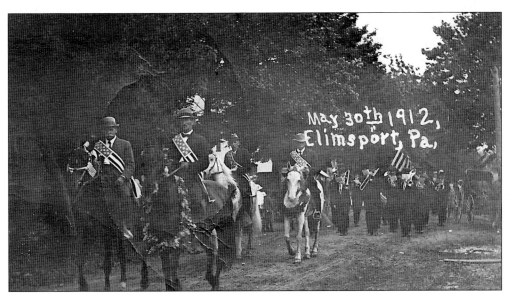

This parade down the main street of Elimsport on Decoration Day in 1912 honored the surviving war veterans in the area. The practice of decorating Civil War soldiers' graves began in the late 1860s, but after World War I, it was expanded to include those who died in any war or military action. (Courtesy of Hugh Christie.)

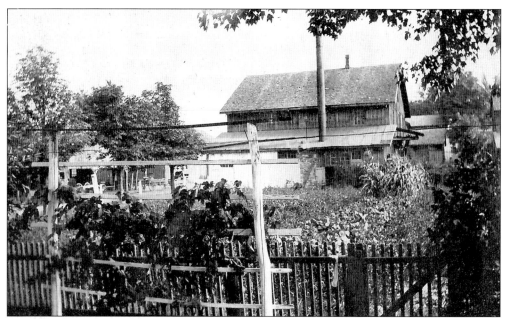

Although a small village, Elimsport had several industries. One of the more important ones was the spoke manufactory of George Bailey and Company. It was first started as early as 1860 as the Bailey and Balliet wagon factory, then it was run by Weaver and Bailey, then by J. F. Weaver and Company. (Courtesy of Eleanor Taylor.)

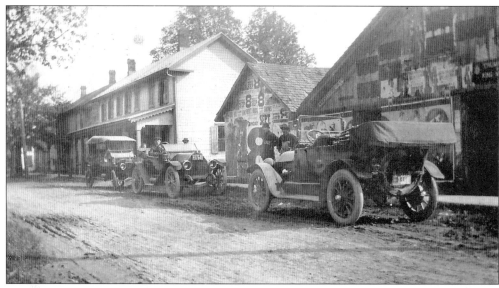

"The Donald" would be dismayed to hear that his was not the first Trump Hotel! The Elimsport Hotel was established by Robert F. McCormick in 1843, but when William Trump took it over in 1884, it became known as the Trump Hotel, famous for its good food and good cheer. The hotel is shown here with the Bodine Garage doing a bustling business next door. (Courtesy of Eleanor Taylor.)

The first post office was established at Elimsport on March 24, 1838, with George Schneider appointed postmaster. Robert McCormick took over as postmaster January 25, 1843, and operated the post office from his store, pictured below, which he started in 1841. His son, William (right), eventually took over the operation of the store and the position of postmaster. William's daughter, Eleanor, remembers as a child trying to resist the lure of her father's post office room, which was referred to as "Uncle Sam's Room." She was not allowed to sit and spin in the chair, press the keys on the typewriter, play with the ink pads and stamps or touch the stacks of mail—things that seemed to be made especially for an afternoon of fun. (Courtesy of Eleanor Taylor.)

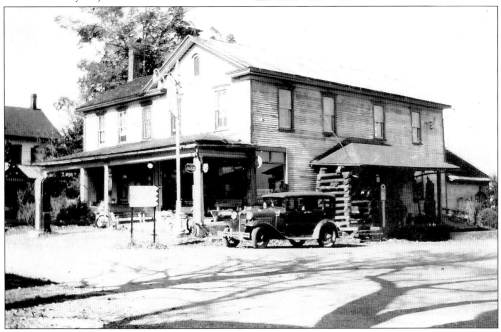

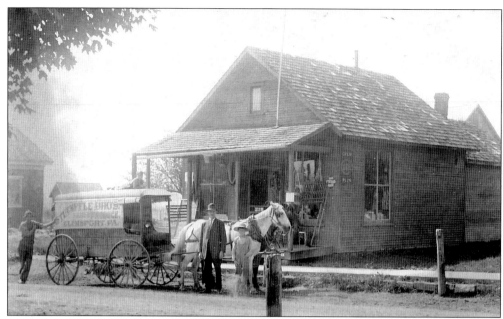

At the beginning of the 20th century, unmarried brothers William and Julius Stuempfle lived with their mother, Christina, on their Elimsport farm in Washington Township. They operated a small general store, which included a produce delivery service. William and Julius are seen in the image above with two boys (one standing by the horse and one on the wagon's roof). The Stuempfle barn is pictured below with a well-tended garden in the foreground. The brothers also owned a tract of land in East Gap upon which they had a logging operation. (Above, courtesy of Eleanor Taylor; below, courtesy of Hugh Christie.)

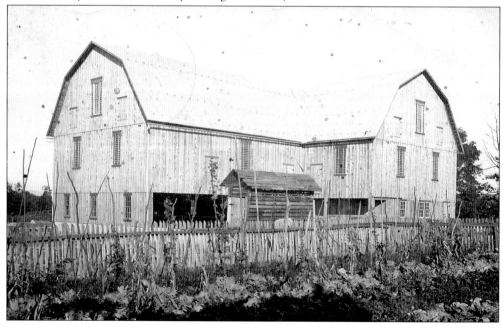

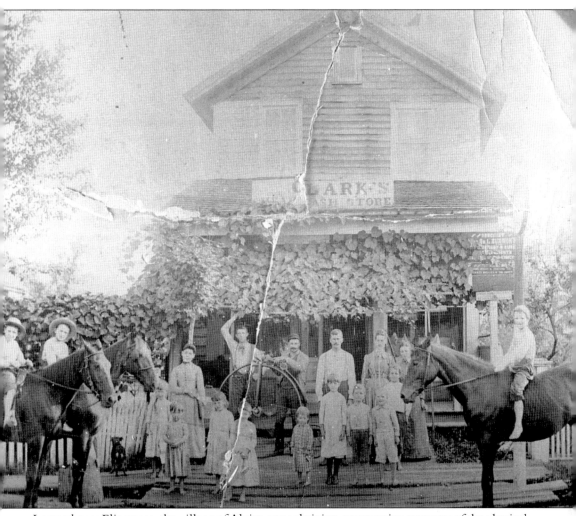

Located near Elimsport, the village of Alvira was a thriving community, unaware of the physical and emotional upheaval it would endure in 1942 when the federal government would force residents to leave homes and property so that a munitions factory could be built. Families were forced to leave the land that their ancestors had settled more than 100 years before. Originally called Wisetown after a local shoemaker named Henry Wise, Alvira was home to over 100 residents, two churches, a post office, two stores, and a schoolhouse by 1900. One of those stores was owned by Jacob H. Clark, seen here with his family and neighbors around 1899. Pictured are (front) Henry Buss and Griffey Foresman (on horses), and the children are Ida Fegley Balliet, Ralph Metzger, Savilla Baker Armstrong, Martha Foresman, Ruth Metzger Decker, Mae Metzger Meek, Luticia (Lettie) Clark Remly, and Fred Metzger (on horse). In the back from left to right are Effie Breon Trye, Wells Kennedy and Elmer Breon (at cycle), Jacob Clark and his wife, Charlotte, and Emma Breon. (Courtesy of Carol and Don Gresh.)

OFFICE OF

H. ELMER BREON,

PRACTICAL ✦ WATCH ✦ MAKER ✦ AND ✦ JEWELER,

DEALER IN

WATCHES, CLOCKS, JEWELRY, SILVERWARE, OPTICAL GOODS,

MUSICAL ∴ MERCHANDISE, ∴ &C,

All Manner of Repairing Pertaining to the Trade Skillfully Done and Warranted.

Alvira, Union Co., Pa., ———————— *189*——

H. Elmer Breon was a respected and successful businessman in Alvira, repairing watches and clocks in addition to selling jewelry. In 1900, David Artman, the village's wheelwright and justice of the peace, wrote of his friend, "By strick [*sic*] attention to his business [Breon] has gained the confidence of his many friends and built up a lucrative business." (Courtesy of the Montgomery Area Public Library.)

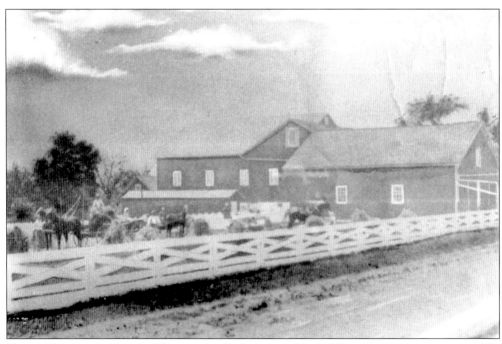

Pictured here are the farm buildings at the Alvira home of Dr. William E. Metzger (see page 100). Metzger was known to rub his chin whiskers to a point as he was diagnosing the ailments of his patients. He was also remembered as proclaiming the distinctive oath, "Begorrah!" (a derivative of "by God!") as he arrived at his prognoses. (Courtesy of the Montgomery Area Public Library.)

Metzger's daughter Ruth Decker grew up in Alvira and reminisced about her childhood in an interview shortly before her death in 1983. She remembers buying a gold chain at John "Douty" Miller's general store and the wonderful soft ginger cookies made by Ella Artman, one of two maiden ladies who lived in town. Pictured on this page are two sisters who may have also tasted the warm cookies from Artman's oven. The two hard at work with their hoes in the family garden are Lena and Ruth Irwin, who grew up in Alvira with their parents, Carson and Sylvia. The family's home is seen below, around 1920. (Courtesy of the Montgomery Area Public Library.)

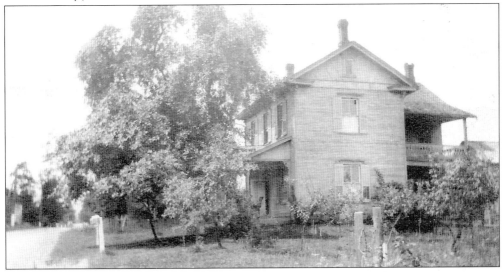

Many longtime Montgomery residents have heard the story of the woman who refused to willingly leave her Alvira-area home in 1942 and had to be carried off her porch while she was still sitting in her rocking chair. Pictured here on their porch are Bruce Solomon and his wife Mary (or Blanche, as she was called) just a few years before her infamous chair ride. (Courtesy of Paul Metzger.)

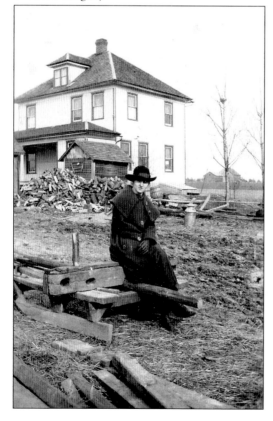

Depending on the random determination of borderlines, some houses in the Alvira area were allowed to remain standing in 1942 when the government took over much of the property for its use. This home was spared during the turmoil of those years. Mary "Mame" Farkey poses in front of her home near Spring Garden, where she lived with her husband Robert until his untimely death. (Courtesy of Allen and Gay DiMarco.)

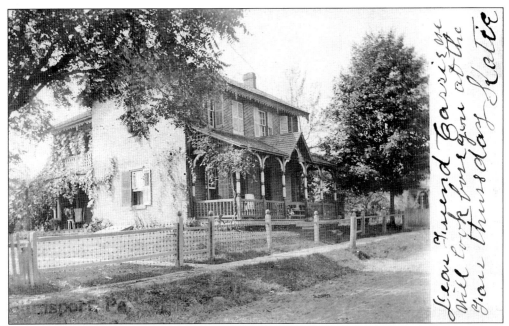

While many of the homes that were built over 100 years ago no longer exist, some still stand as a testimony to the fine workmanship of the builders at that time. Some retain the original charm and decorative details, but others, like this house on Gap Road, have been totally transformed and renovated. (Courtesy of Marion McCormick.)

William Piatt was born in 1795, the son of John Piatt, one of the early settlers of Brady Township who established a tannery there. Although William learned the tannery trade, he also became interested in politics. He was elected to the Pennsylvania General Assembly during the 1830s and in 1855, was chosen to be associate judge. The Piatt family farmhouse is seen above. (Courtesy of Eleanor Taylor.)

On April 9, 1912, Dr. William Devitt from Philadelphia purchased a 60-acre tract of land about two miles west of Allenwood. For $850, his dream of establishing a secluded camp in the country for his patients who had contracted tuberculosis became a reality. The camp offered accommodations for both the afflicted person and for his family. During the early 1900s, tuberculosis was viewed as an incurable disease but Devitt's approach to the treatment of this deadly disease included daily sunbaths, regular exercise and activity, and trips made to a central dining hall for meals (see below). At left are Devitt and his wife, Laura, as they wait for the train at Milton station to take them on a brief winter holiday to Florida. (Left, courtesy of Jack and Bill Devitt; below, courtesy of the Montgomery Area Public Library.)

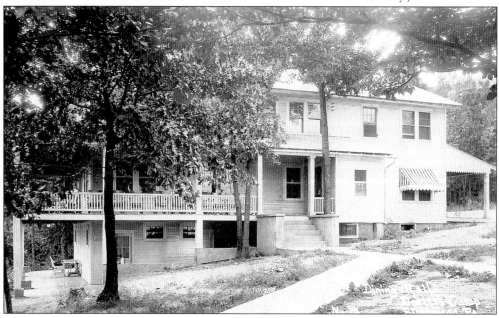

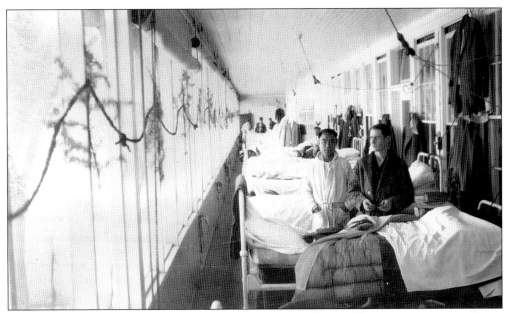

One of the features of Devitt's Camp was its innovative living accommodations. In *The Story of Devitt's Camp*, a historical account of the camp printed in 1937, the first cabins were "simple affairs, light but sturdy, and designed to admit the greatest possible amount of air and light. [They were] open to the front, where the ill practically lived on sleeping porches." These screened porches are seen above in this photograph of an early men's ward. Below is an example of more comfortable accommodations that were available by the 1930s when tuberculosis treatment included less emphasis on fresh air and more on physical rest and medical advances. When penicillin was discovered, it was the cure for sufferers of tuberculosis but it also meant the demise of Devitt's Camp; it closed in 1956. (Courtesy of Phoebe Ministries.)

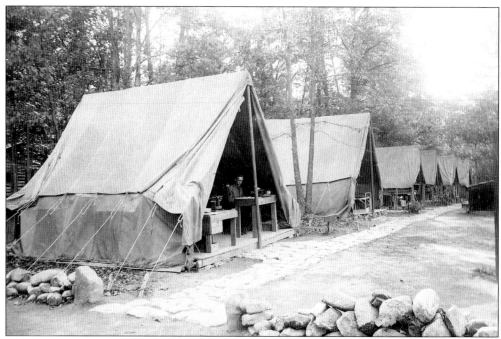

On April 30, 1933, Civilian Conservation Corps (CCC) Company No. 366 set up camp near Elimsport. It was one of the earliest camps established after Pres. Franklin D. Roosevelt enacted Emergency Conservation Work Act on March 31 in an effort to create jobs for the approximately 13 million people who were out of work at the time. Enrollees into the CCC had to be unemployed, unmarried, and between the ages of 18 and 26. Hard physical labor was required to perform the road building, forestry labor, and flood control, and accommodations were primitive. Tents were pitched when the camps were first established, as seen above, and then more permanent log cabins were erected. The Elimsport camp was open for more than five years and became an integral part of the community. (Courtesy of the James V. Brown Library Archives.)

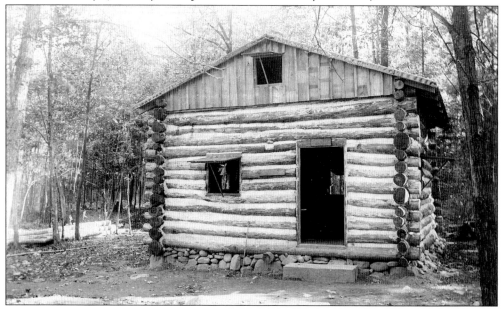

Beginning one mile north of Elimsport, State Route 554—also known as Sulphur Springs Road—travels for nine miles north over the mountain into South Williamsport. Pictured here in a muddy, rutted condition, this windy back road was not paved until the 1930s. (Courtesy of James V. Brown Library Archives.)

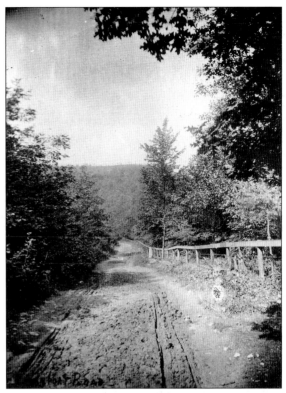

Now known as U.S. Route 15—a major highway that extends from South Carolina north into New York—the section locally referred to as the Montgomery Pike opened in October 1930. Before the road was improved, tolls were collected at the top of the mountain to fund any repairs or grading that were necessary to make the dirt road passable. (Courtesy of Vincent Hall.)

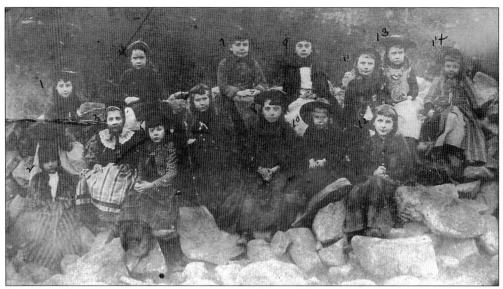

Known locally as the Devil's Turnip Patch, this geological phenomenon known as a boulder field is located along the Montgomery Pike in northern Clinton Township. It has attracted both local sightseers and travelers from out of the area. The photograph above is dated 1894 and shows a group of local girls at the patch, from left to right, (first row) Minnie Burley (2), Sue Fritz (3), Carrie Reid (5), Edna Farley (6), Nell Felsberg (8), Beulah Love (10), and Mabel Love (12); (second row) Eva Pysher (1), Ruth Sterner (4), Viola Heddius (7), Emma Bruner (9), Maude Stouser (11), Myrtle Love (13), and Pauline Housel (14). Below is a later view of the stones at the Devil's Turnip Patch with two unidentified ladies. (Above, courtesy of the Montgomery Area Public Library; below, courtesy of Marion McCormick.)

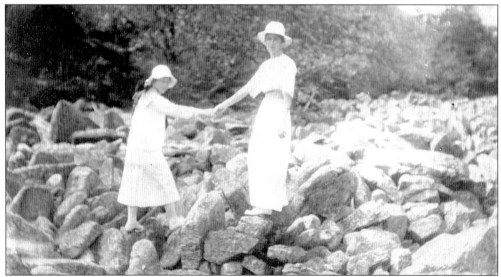

Nine

CAUSE FOR CELEBRATION

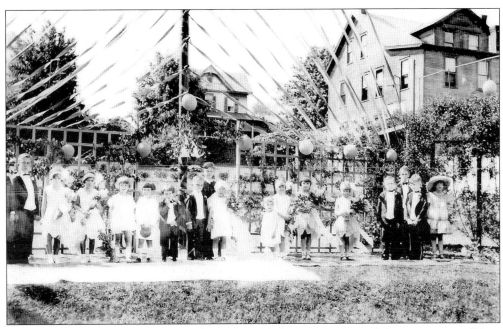

Many popular forms of entertainment often involved the children of the community. "Tom Thumb weddings" were organized by dressing children in formal wedding costumes to replicate the 1863 wedding of P. T. Barnum Circus performers Gen. Tom Thumb and Lavinia Warren. The celebration pictured above, however, seems to be a May Day party that took place in 1929 at the Decker mansion. The boy at the left of the photograph is identified as E. K. Shollenberger when he was about five years old. (Courtesy of Edward Miller.)

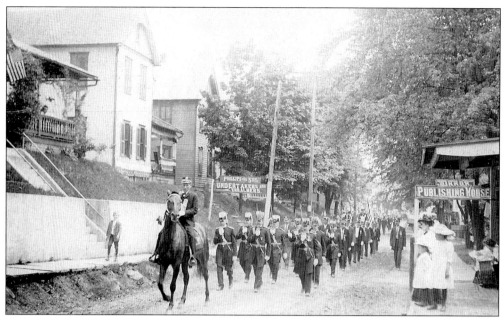

In this parade scene, the *Montgomery Mirror* newspaper headquarters can be seen on the right and the office and business establishment of William E. Phillips, who provided mortuary and funeral services, is advertised on the hill at the left. He was a cabinetmaker in Turbotville and then worked in a Williamsport furniture factory until 1908. That year, Phillips moved to Montgomery where he opened his office on Main Street. (Courtesy of Lynn Ditty.)

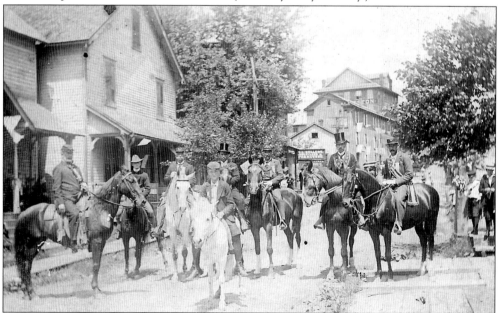

Organized in 1891, this group of members of the Independent Order of Odd Fellows, John Brady Encampment, ready themselves for a parade down the streets of Montgomery. In 1901, the group joined members of the GAR, the POS of A, and Junior OUAM as they marched together to the Montgomery Opera House to attend the community memorial service for the late Pres. William McKinley. (Courtesy of the Montgomery Area Public Library.)

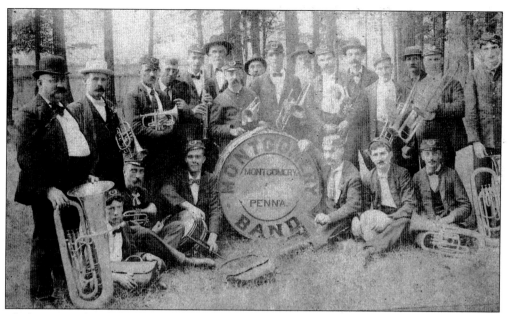

The borough's first band was formed in 1879 and was led by R. M. Fowler. Their weekly practices were held on the banks of the Susquehanna River. In 1884, another band was organized by Preston Gowers and, at one time, practiced in a blacksmith's shop. By 1912, their instruments were in need of repair but no funds were available so the band was disbanded. (Courtesy of the Montgomery Area Historical Society.)

GREAT DEBATE ON

WOMAN'S SUFFRAGE

OPERA HOUSE, MONTGOMERY, PA.

FRIDAY, MARCH 28, '13

AT 8:00 O'CLOCK

REV. AARON NOLL

REV. AARON NOLL will Discuss
the Affirmative

MR. WILLIAM DECKER the Negative

Held under the Auspices of the
Parent-Teachers' Club. Benefit
to the Library Fund

The 19th Amendment to the Constitution, which allows the right to vote "not to be denied . . . on account of sex," was ratified in August 1920. The debate on whether or not women should be allowed to vote had begun long before that, however. In Montgomery, a debate was held on the subject in March 1913, with Rev. Aaron Noll and William Decker taking opposite sides. Reserved seating could be secured for 20¢; general admission cost a dime. (Courtesy of the Montgomery Area Historical Society.)

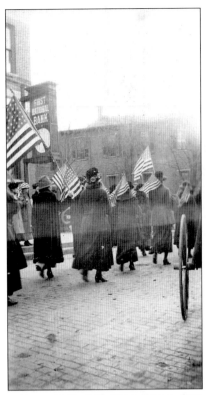

On November 11, 1918, word was received by the townspeople of Montgomery that an armistice had been reached between the Allies and Germany. In the crowd pictured at left, Bertha, Myrtle, and Beulah Love, and Beulah Shelley, four young women who had two brothers in the war march with other Montgomery residents. The crowd grew in numbers and the celebration continued on the streets of Montgomery (below). Within the next few months, all but six of Montgomery's troops returned home. The six who sacrificed their lives included Raymond C. Bartlett, Freeman W. Bower, Lloyd L. Manley, Charles K. Mull, Russell Shoemaker, and Judson Strong. These six were remembered with a memorial in 1927. For more information about this memorial, see page 41. (Courtesy of the Montgomery Area Public Library.)

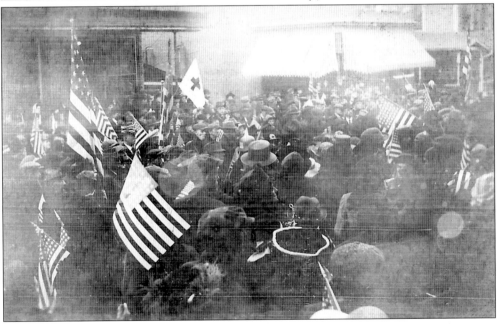

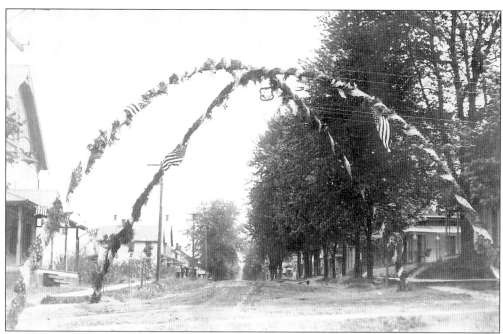

Montgomery hosted a convention for the Junior OUAM during the early 1900s. Large arches were erected over the streets, welcome banners were hung, and bands and marchers greeted the visitors as they arrived by train. At the top of the arch (above) hangs the symbol for the Junior OUAM—a shield surrounding an arm and hammer (symbolizing strength and leadership), the square (symbolizing truth), and the compass (symbolizing the Deity). The Montgomery Council No. 511 was organized October 16, 1891, with 71 loyally patriotic members. To the left of the pole, in the picture at right, a large poster advertises the Carl Hagenback and Great Wallace Combined Shows—a trained animal and circus show that operated between 1907 and the 1930s. (Above, courtesy of Marion McCormick; right, courtesy of Hugh Christie.)

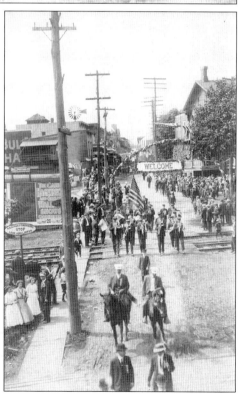

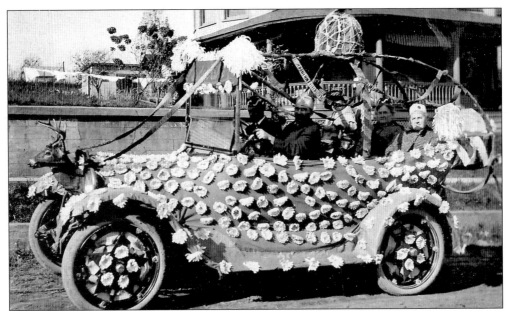

Dr. John Frank Gordner posed with his mounted moose on page 30; this participant in another one of Montgomery's parades attached a mounted deer head to the front grille of his automobile. A couple hundred tissue paper flowers decorated this possible entry in the "Best Decorated Car" category. (Photograph by E. K. Shollenberger, courtesy of the Montgomery Area Historical Society.)

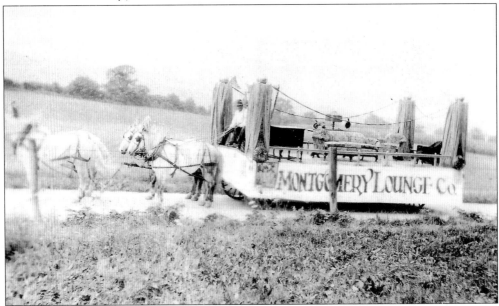

Montgomery Lounge Company offered this parade entry, which displayed their newest styles of upholstered furniture. Another way that businesses advertised their products was to rent space to set up displays for prospective customers to see the newest lines. In July 1907, the Montgomery Table Works, the Penn Furniture Manufacturing Company, and the Montgomery Furniture Company closed their factories for two weeks during the furniture show they held that year. (Courtesy of Edward Miller.)

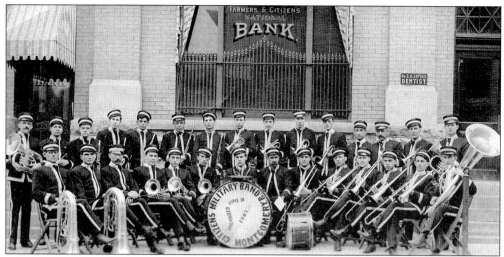

The Citizens Military Band (see also back cover) was formed in 1907 and performed in many services and celebrations before it disbanded in 1922. From left to right, members are (first row) Elmer Stugart, Jobbie Diehl, Abner Housel (director), John Wagner, Freeman Hauke, Aaron Wagner, Karl Fowler, Elias Fullmer, Leaman Nuss, Benjamin Overdorf, Maurice Stover, Oscar Steel, Raymond Barlett, and Harry Fullmer; (second row) Sam Pursell, Paul Leinbach, Dunbar Shollenberger, John Grady, Boyd Hartzel, Harry Lee, Cloyd Diehl, Claude Miller, Howard Hughes, Clyde Fullmer, Freeman Houser, Wilson Stewart, Robert Miller (manager), Seth Sterner, and Edward Hagenbach. A few of the younger members of the Citizens Military Band take a break after a parade (around 1910–1915). From left to right are Fred Koons, Harry Follmer, Howard Hughes, Karl Fowler, Freeman Houser, and Boyd Hartzel. (Courtesy of the Montgomery Area Historical Society.)

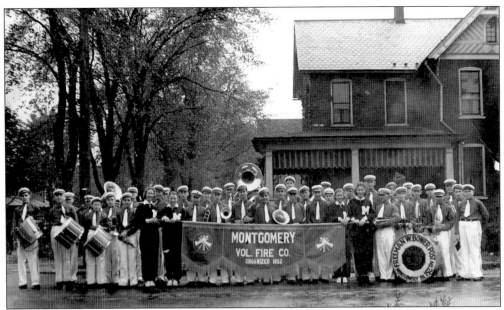

The 40-piece American Legion Band was formed in December 1925 with these members. From left to right are (first row) Donald Grady, Lamont Stewart, Francis Grady, ? Kennedy, Bob Grady, Helen Meek, Louise Zellers, Earl Hain, ? Buck, Keith Hafer, Frank Hall, Carl Nuss, Joe Barlett, Peg Bardo, Lois Miller, Tucker Barlett, unknown, Joe Phillips, Cecil Fowler, Dick Breon, and Bill Bensinger; (second row) William Shrey, unidentified, unidentified, Harold Strouse, Robert Reeser, Claude Miller, Ralph Decker, Clarence Strouse, unidentified, Laurence Frontz, five unidentified members, Jack Wagner, unidentified, Richard Buck, Oden Horn, and band leader C. H. Gowers. In July 1937, the borough celebrated its 50th birthday with a week of parades, band concerts, and organized tours of the community. The semicentennial headquarters was at the old Love Hardware store at the corner of Main and Houston, seen below. (Courtesy of the Montgomery Area Public Library.)

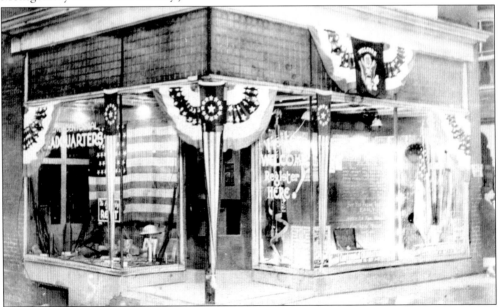

Ruth Turner (right) was crowned the queen of Montgomery's semicentennial. She was the daughter of Dr. Wilbur E. Turner who penned an article in 1962 titled "Reflections of a Family Doctor" in which he reminisces about the past and his memories of Montgomery. At the end of his musings, he writes, "The keeping of a diary is probably a good or not so good practice, depending on what one writes in it. One could begin no earlier than today to keep a record of present events and look toward the next 25 years when Montgomery will celebrate its Centennial." In 1987, Montgomery celebrated its 100th birthday and in 2012, it will mark its 125th year. Perhaps one should consider taking the doctor's advice. (Right, courtesy of the Montgomery Area Public Library; below, courtesy of the Montgomery Area Historical Society.)

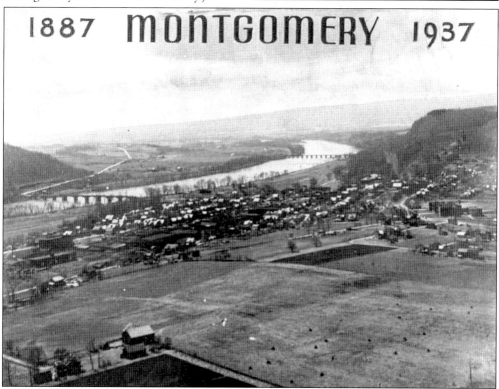

1887 MONTGOMERY 1937

ACROSS AMERICA, PEOPLE ARE DISCOVERING SOMETHING WONDERFUL. *THEIR HERITAGE.*

Arcadia Publishing is the leading local history publisher in the United States. With more than 3,000 titles in print and hundreds of new titles released every year, Arcadia has extensive specialized experience chronicling the history of communities and celebrating America's hidden stories, bringing to life the people, places, and events from the past. To discover the history of other communities across the nation, please visit:

www.arcadiapublishing.com

Customized search tools allow you to find regional history books about the town where you grew up, the cities where your friends and family live, the town where your parents met, or even that retirement spot you've been dreaming about.